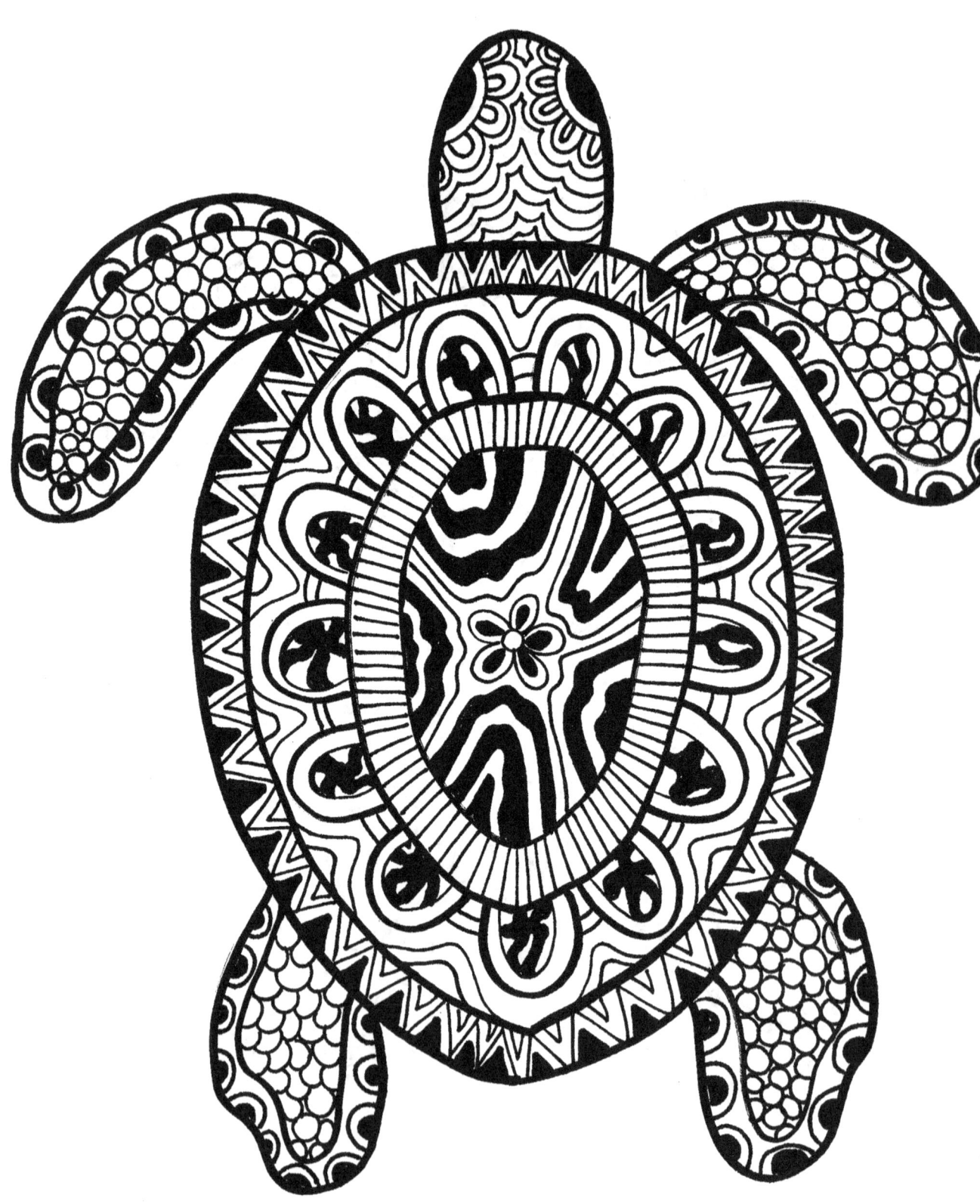

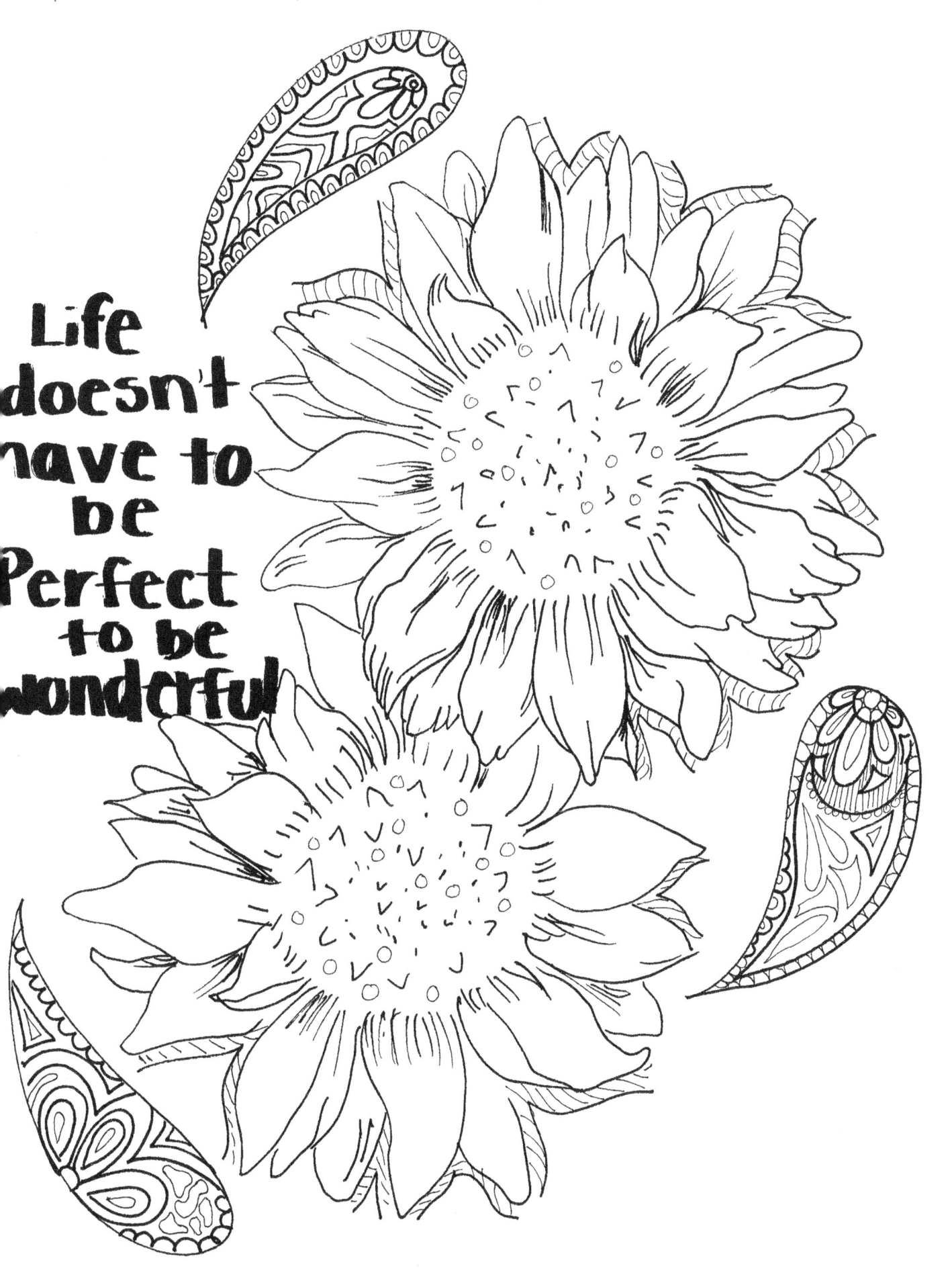

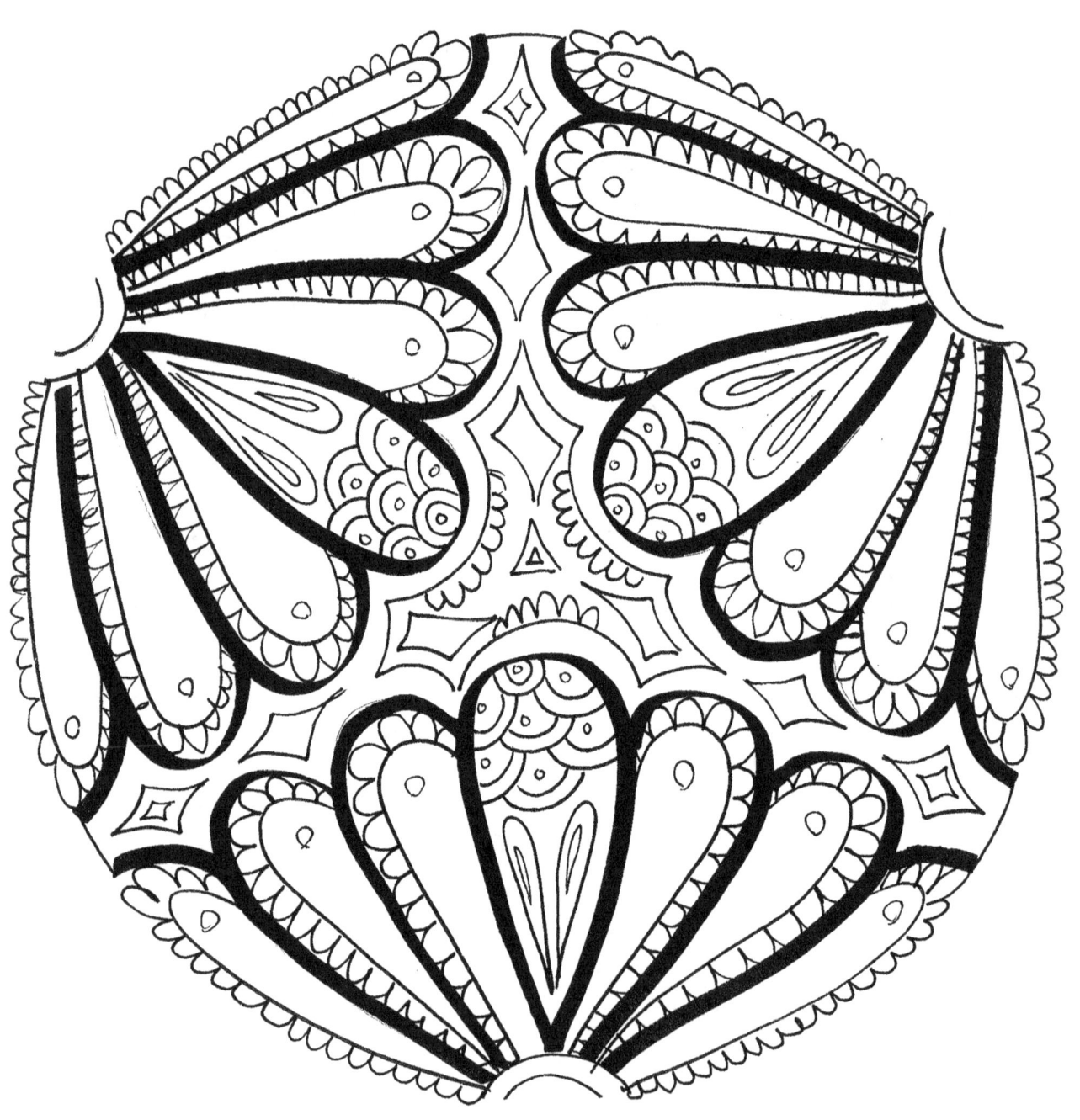

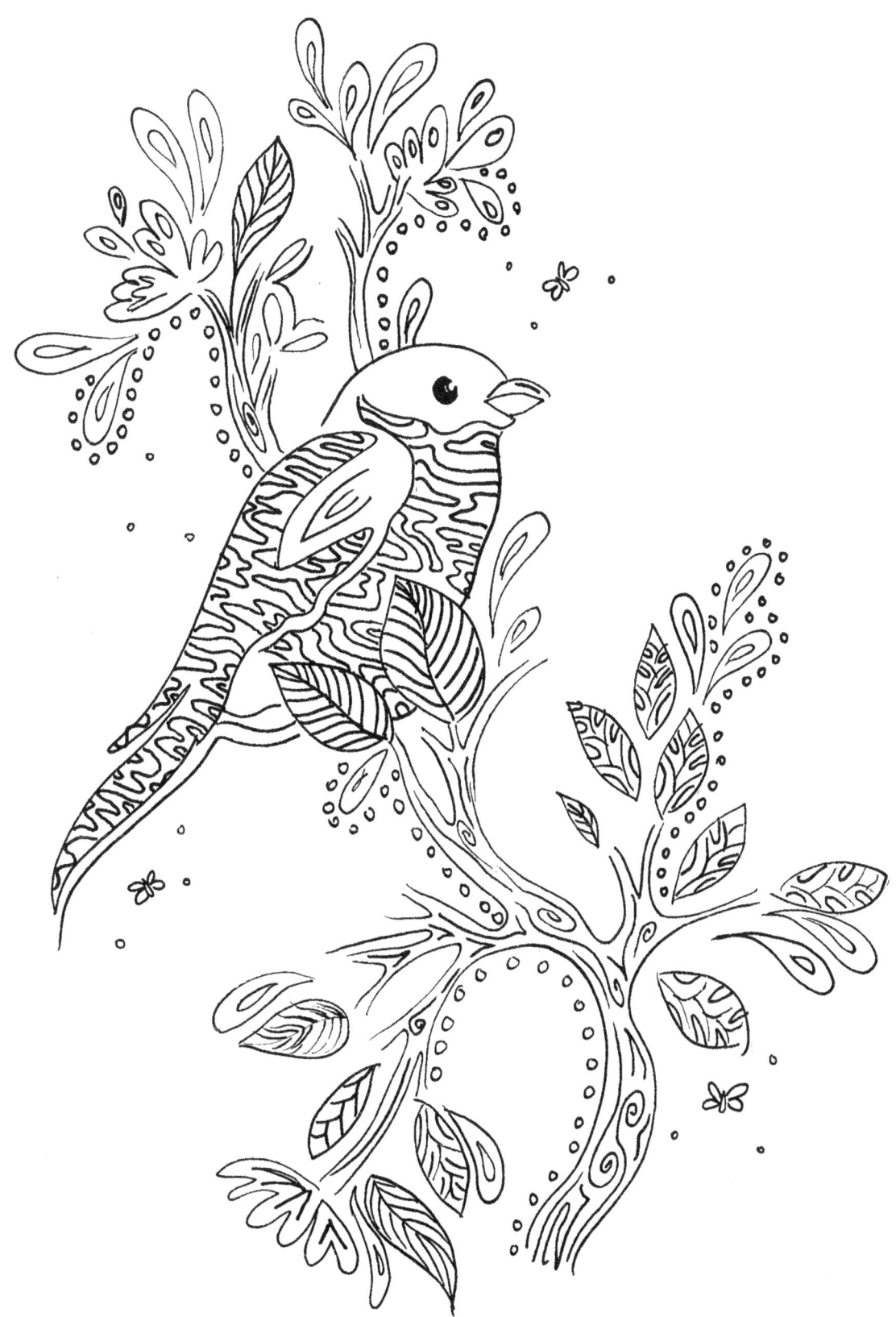

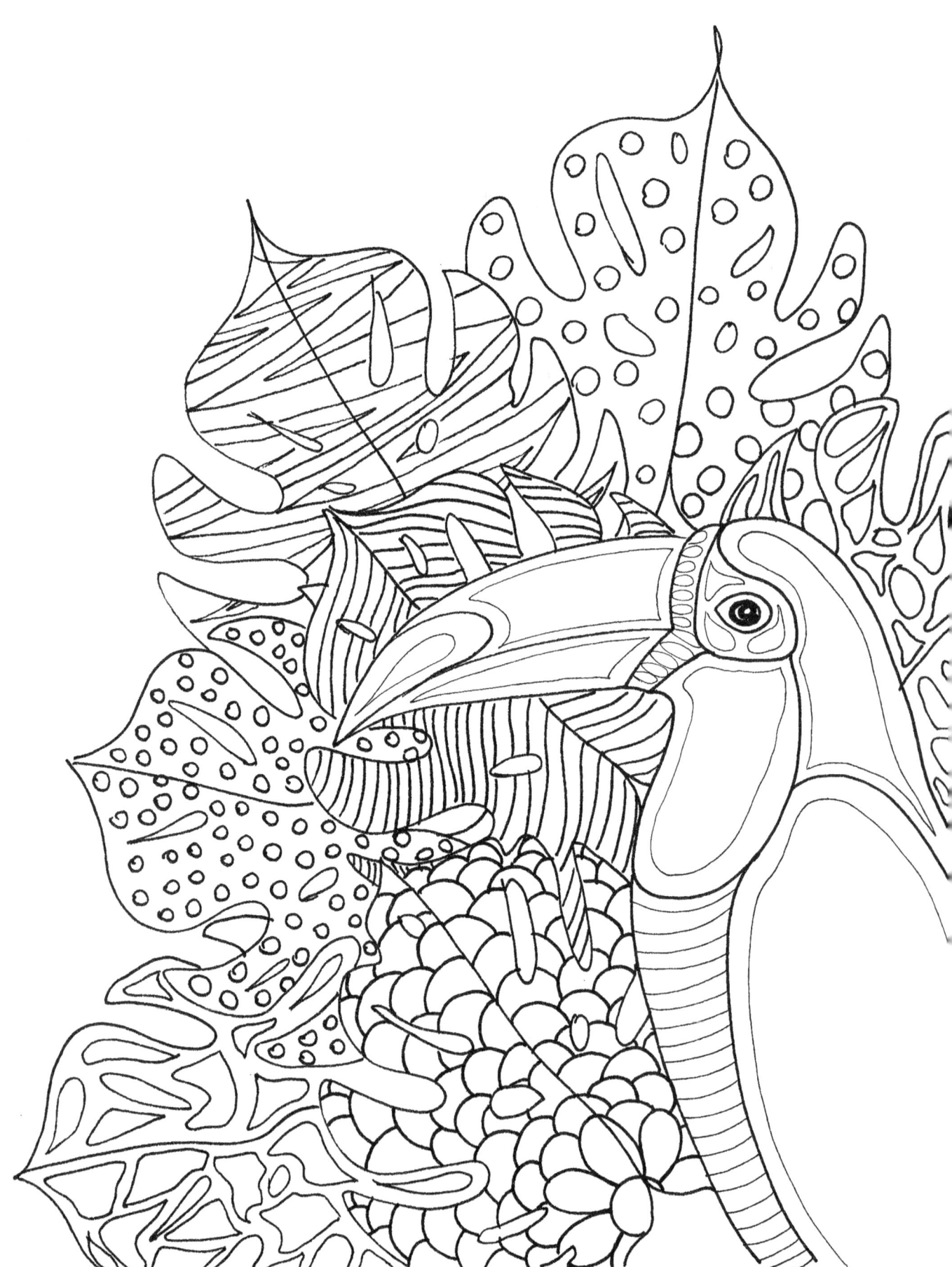

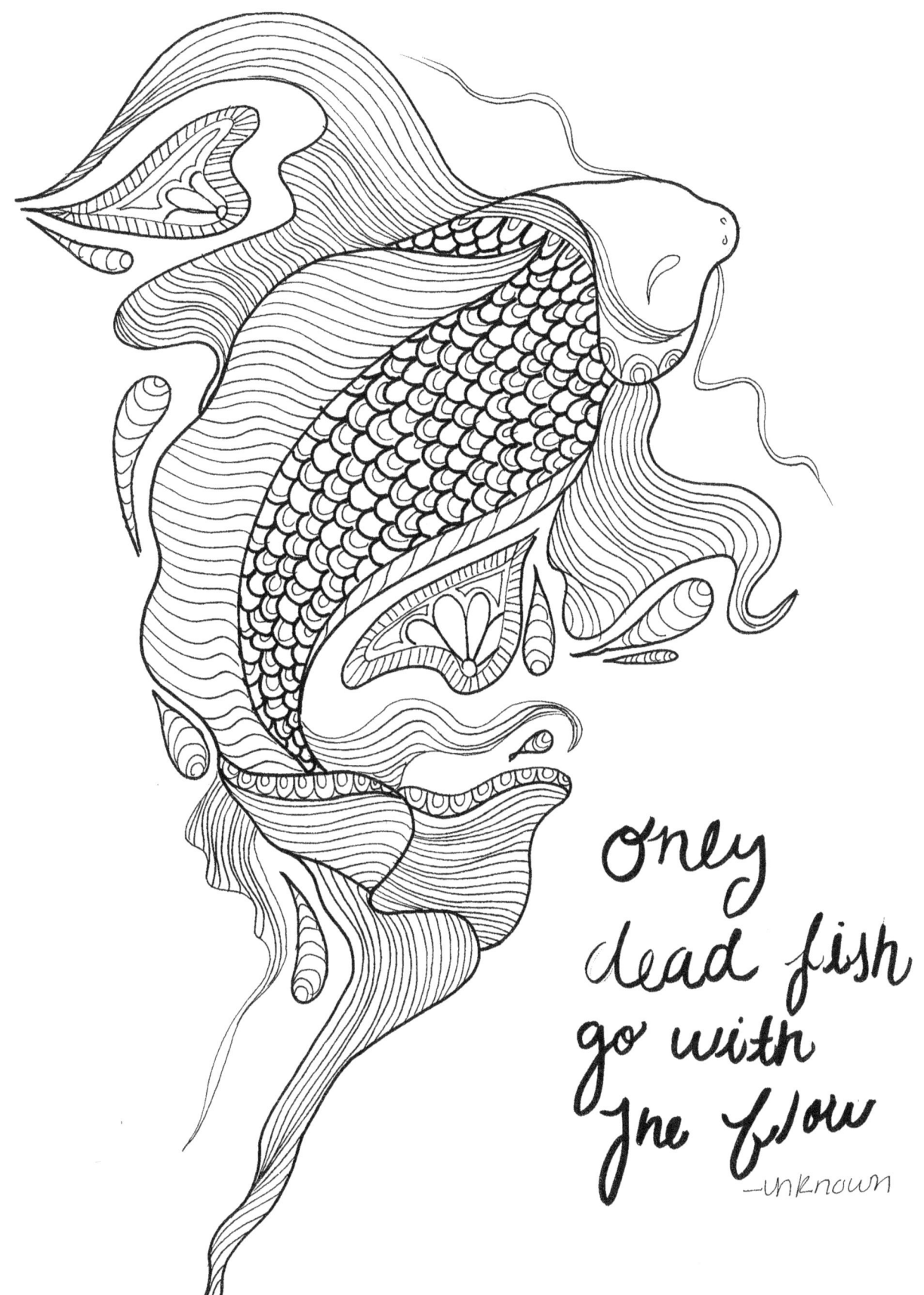

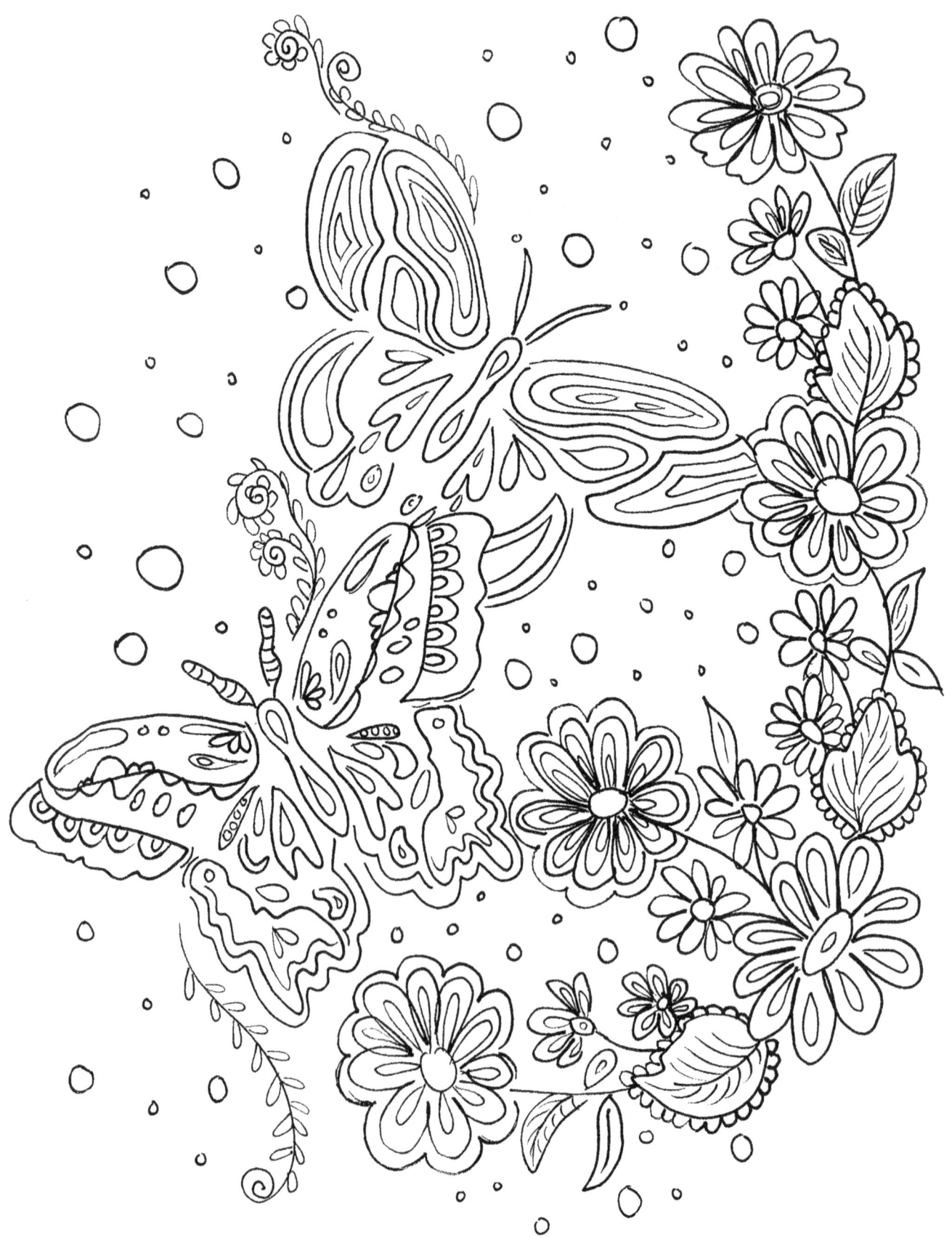

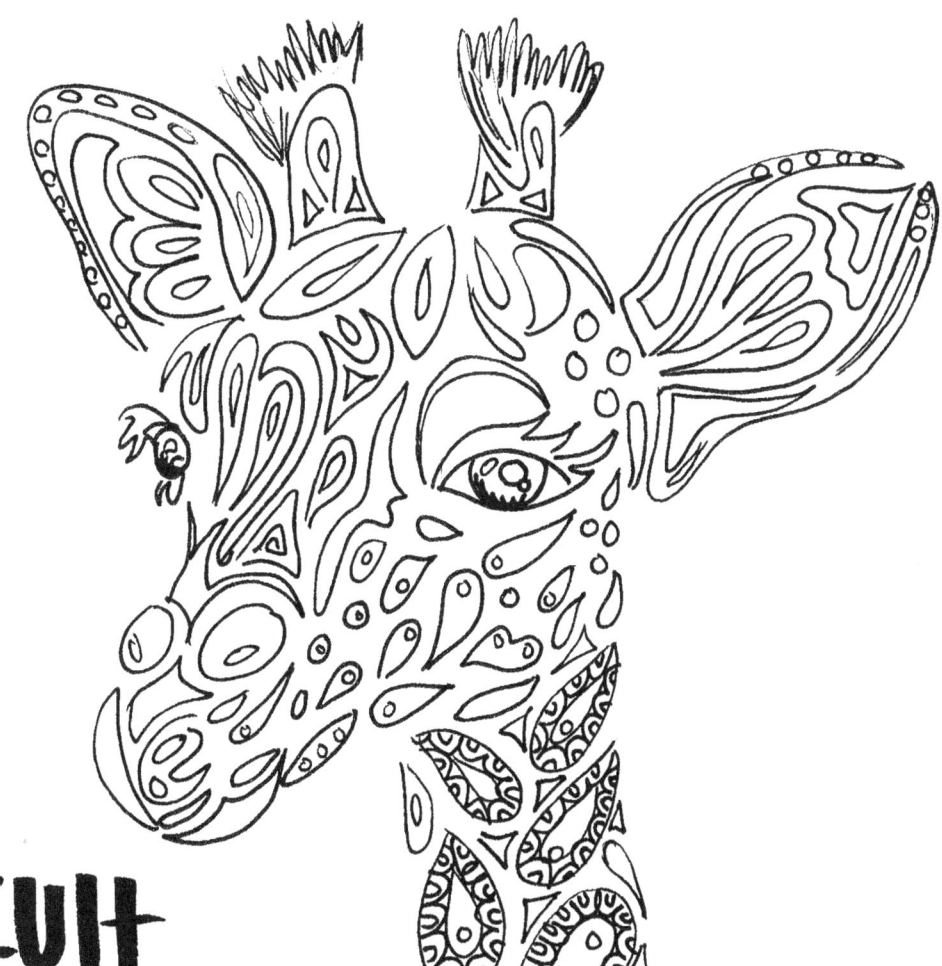

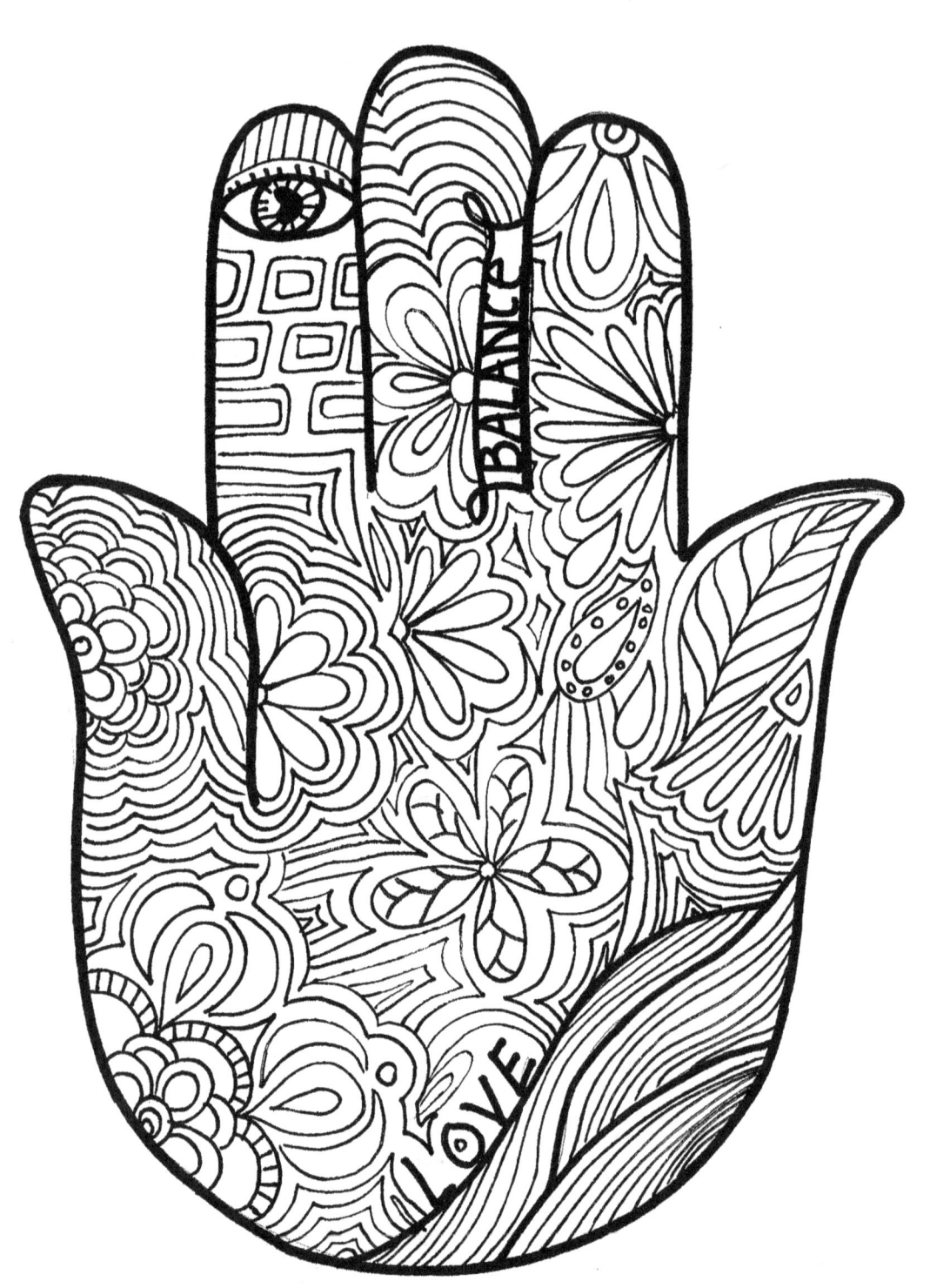

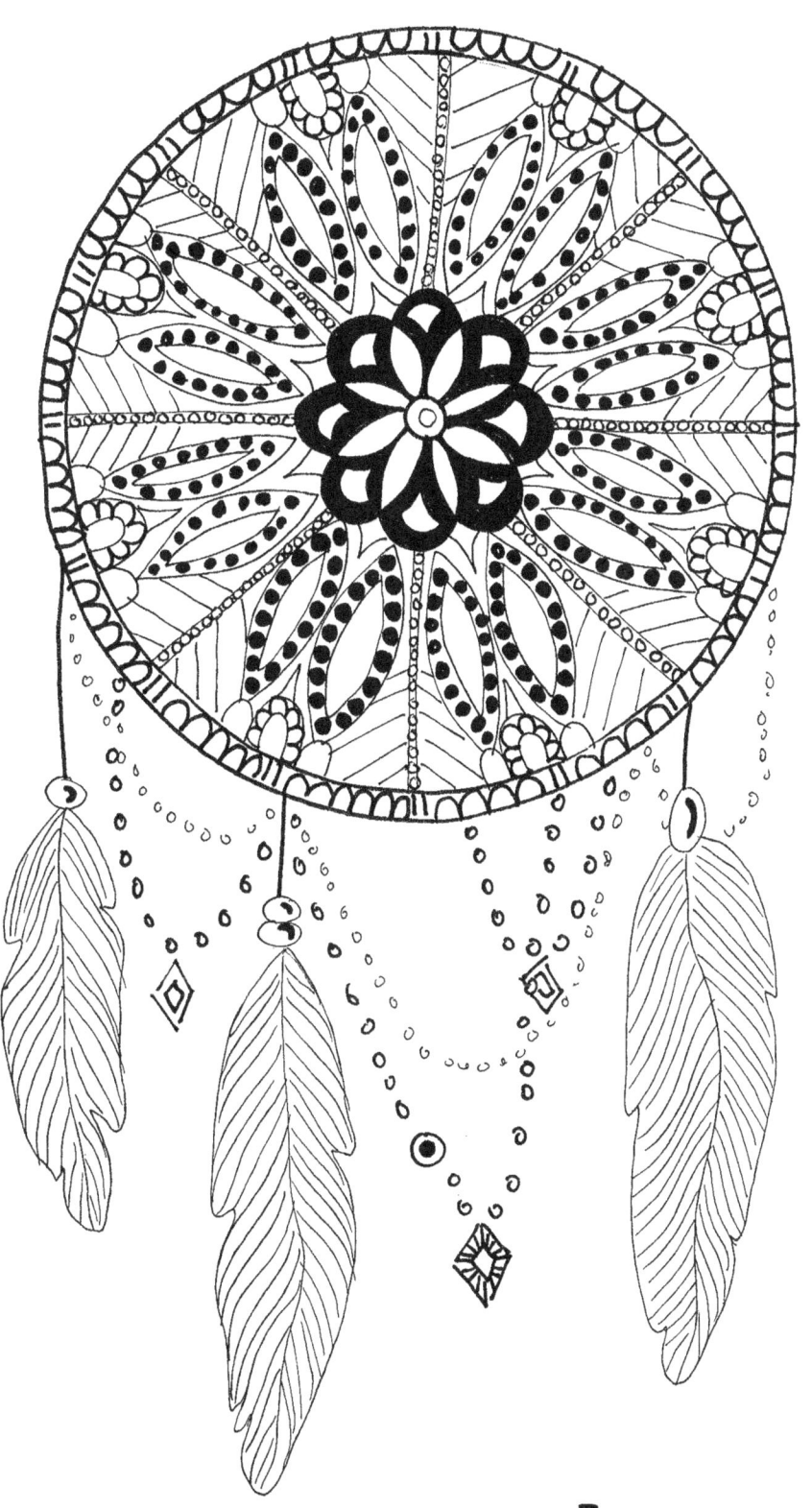

Build your own dreams....

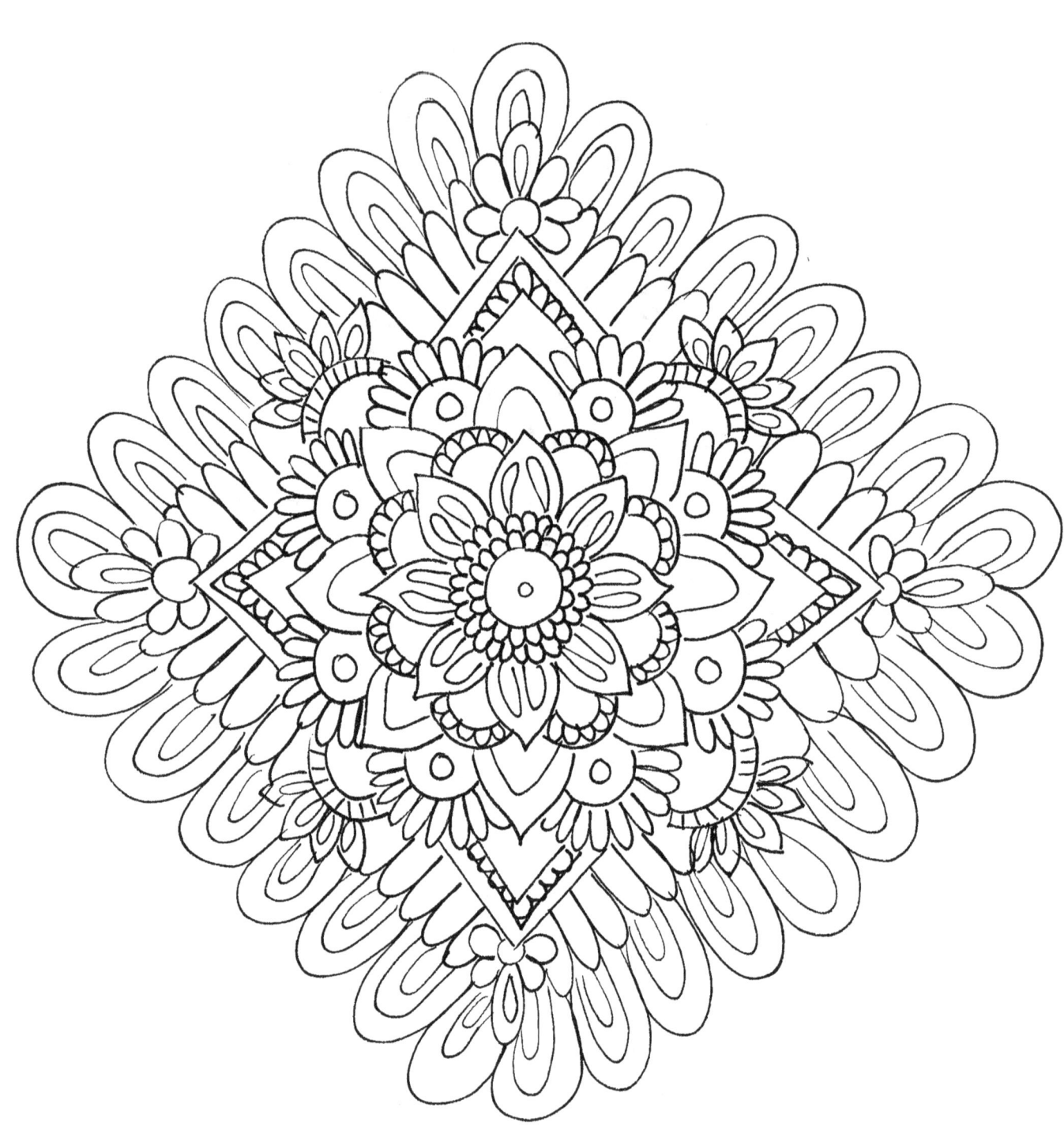

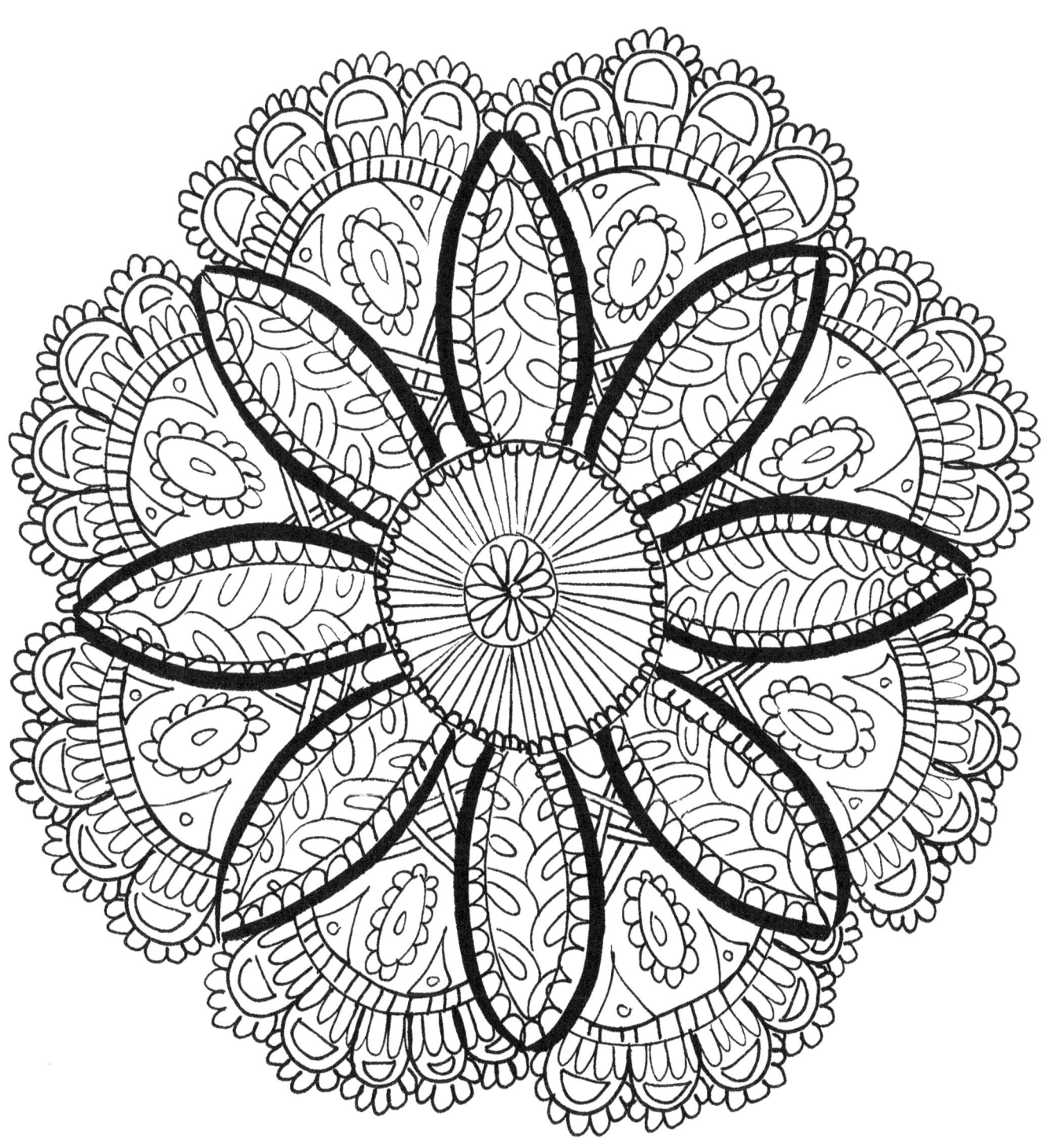

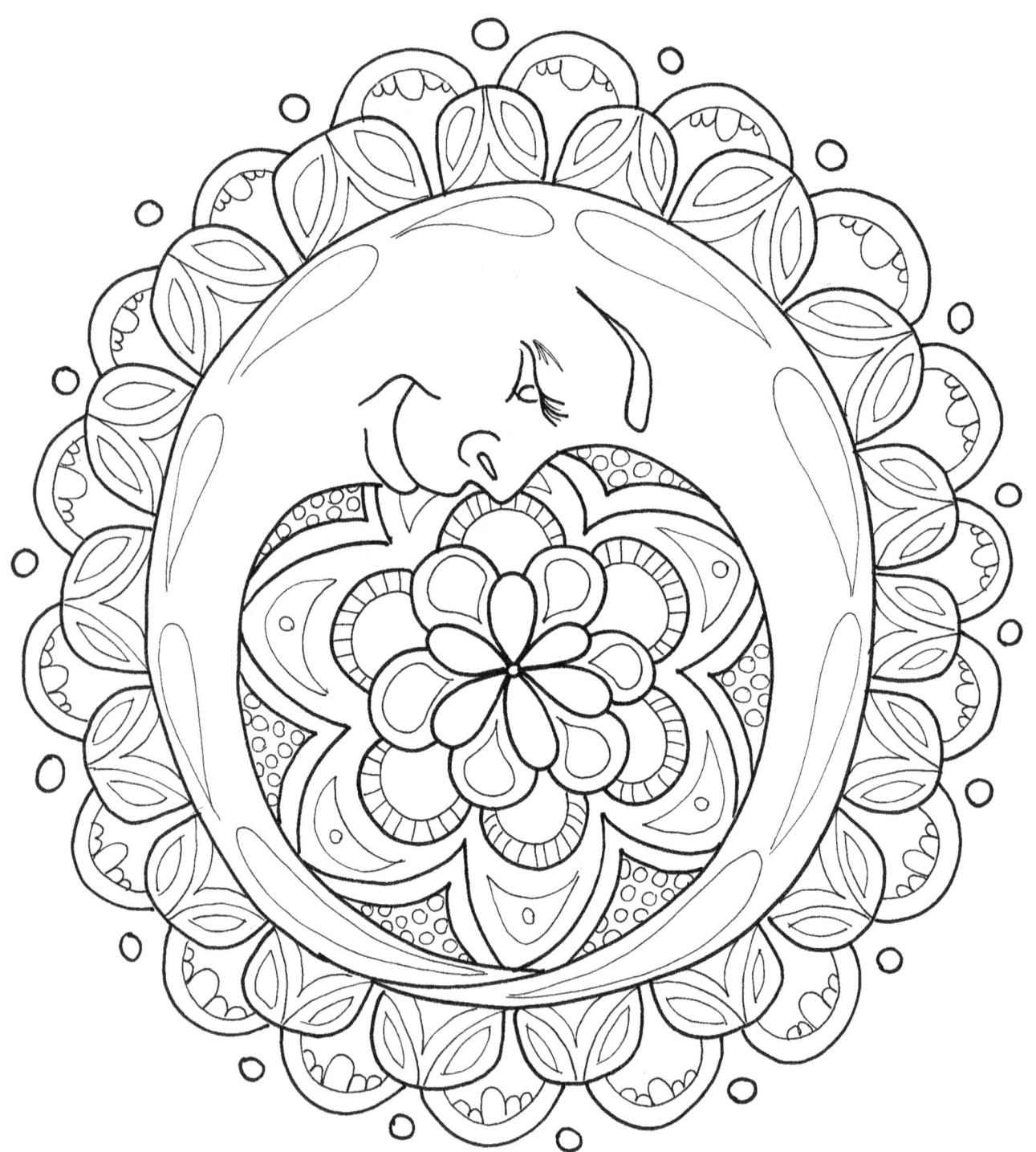

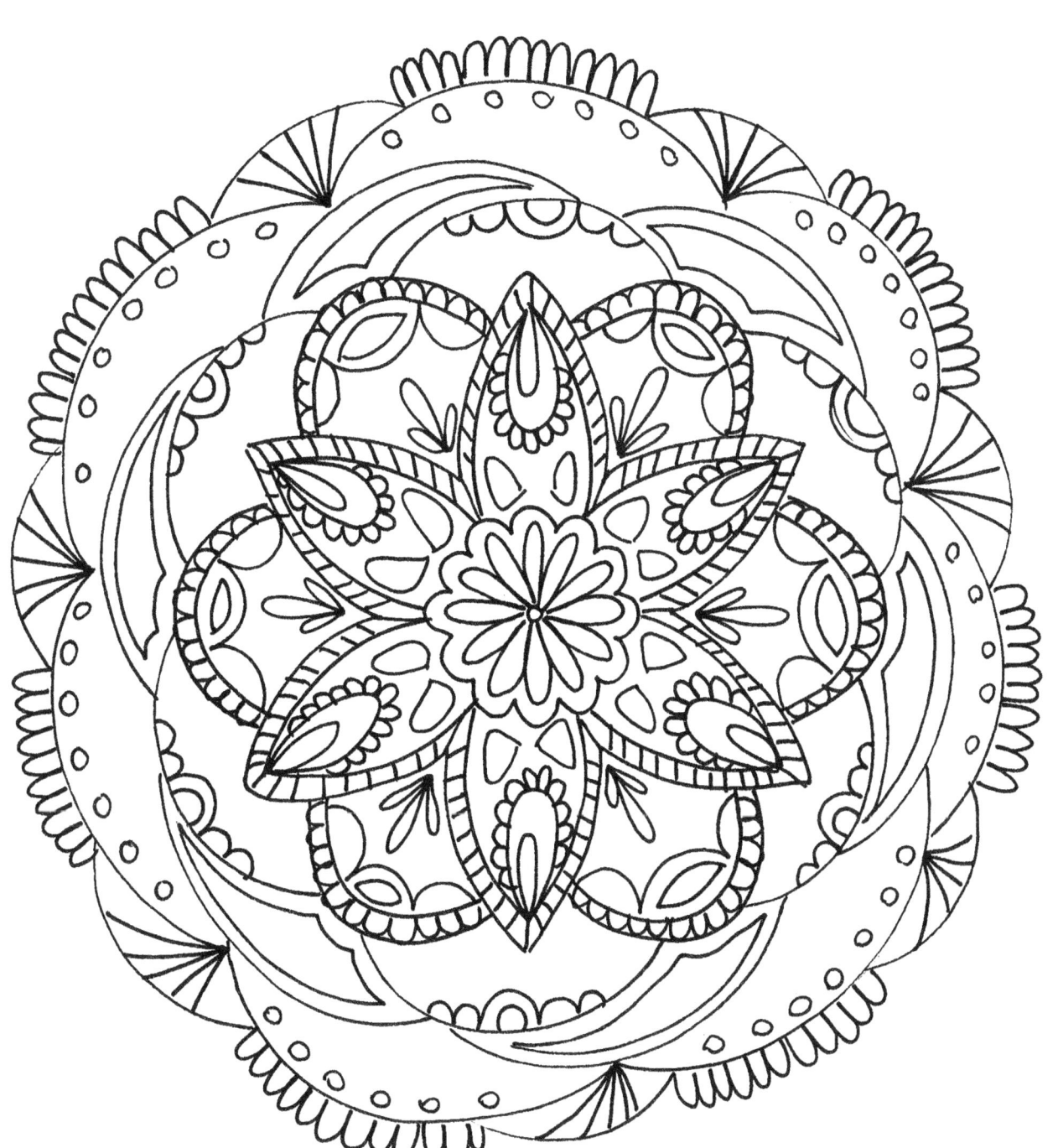

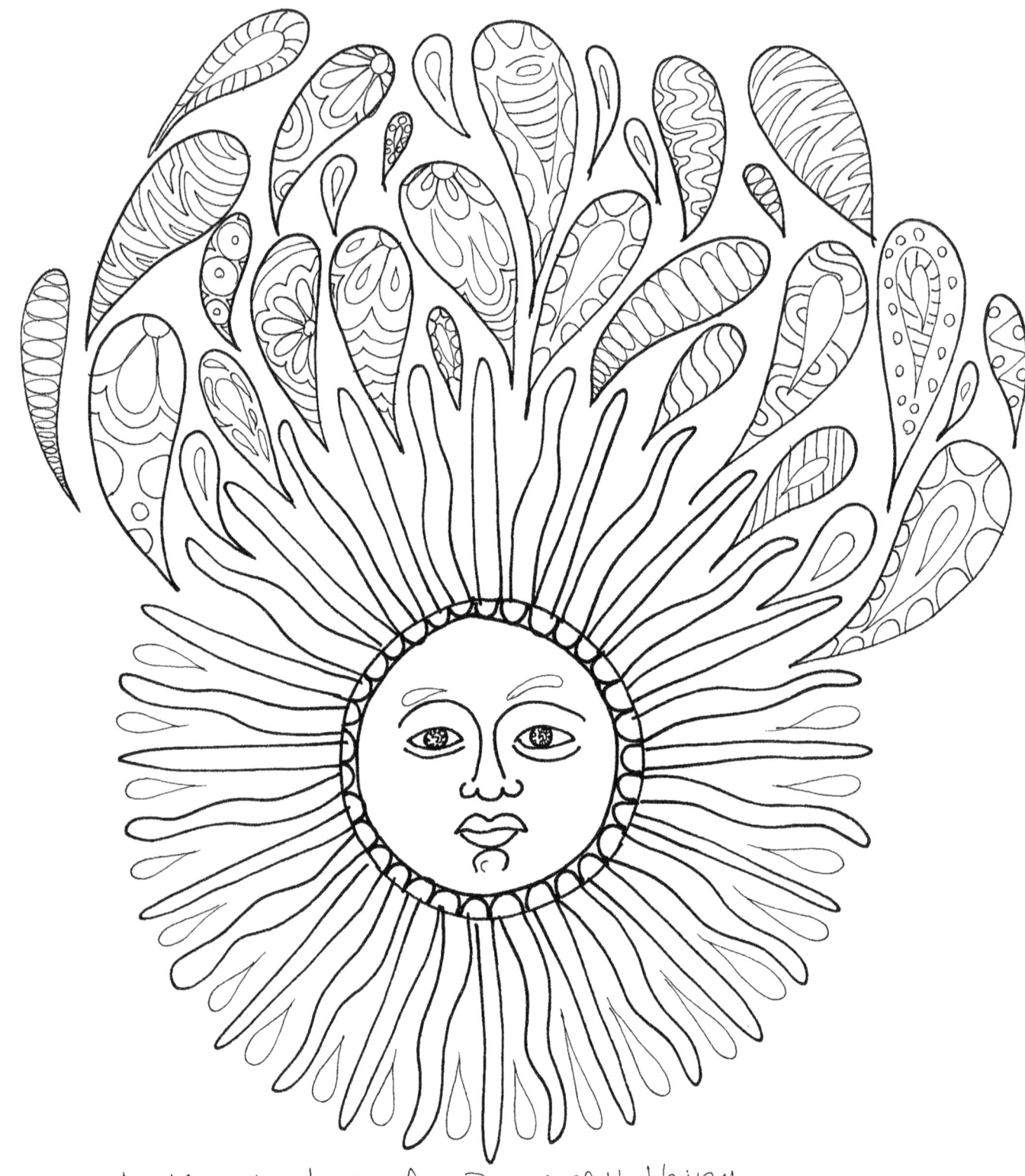

your mind is A Powerful thing. when you fill it with positive thoughts, your life will start to change.

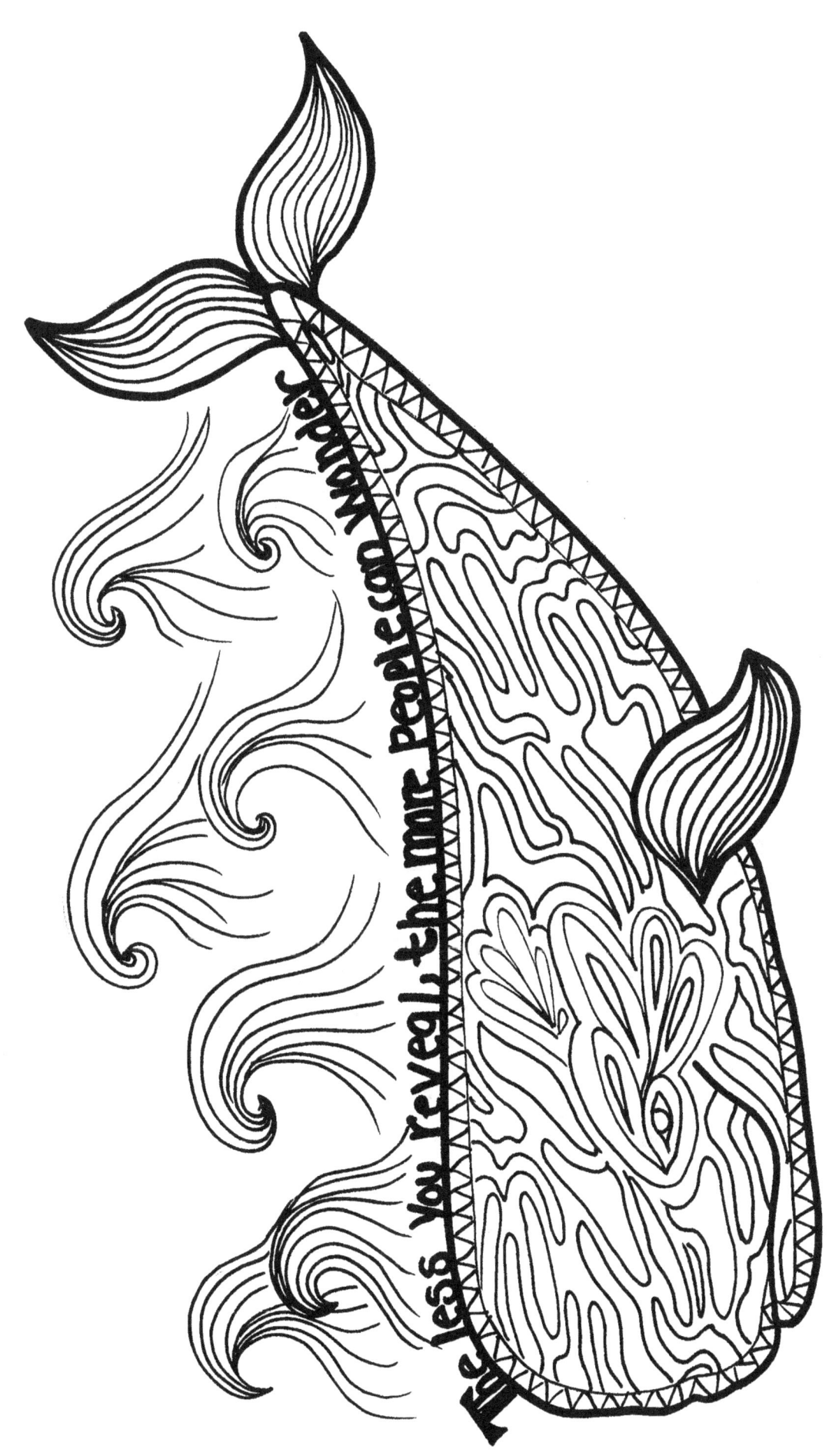

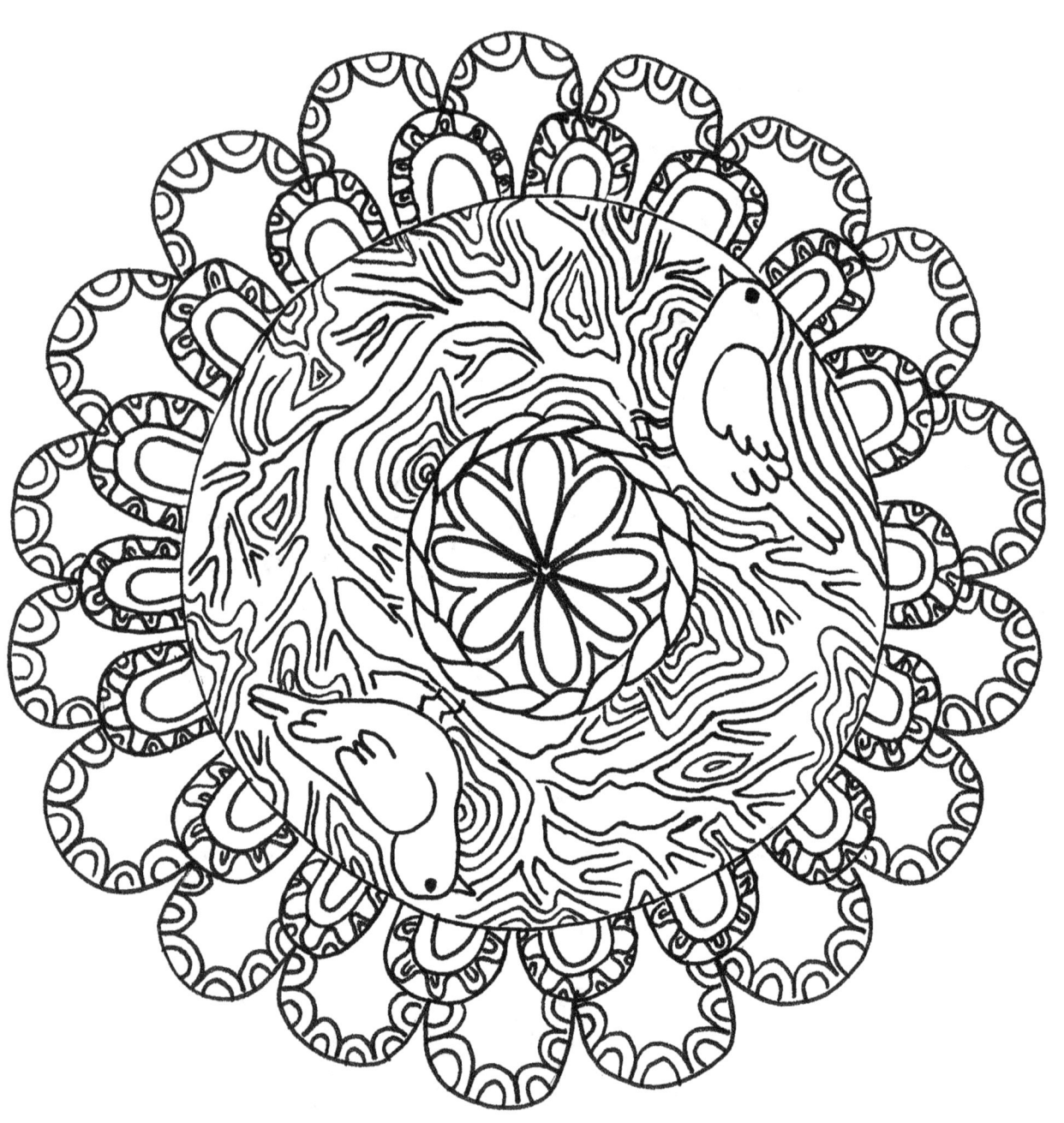

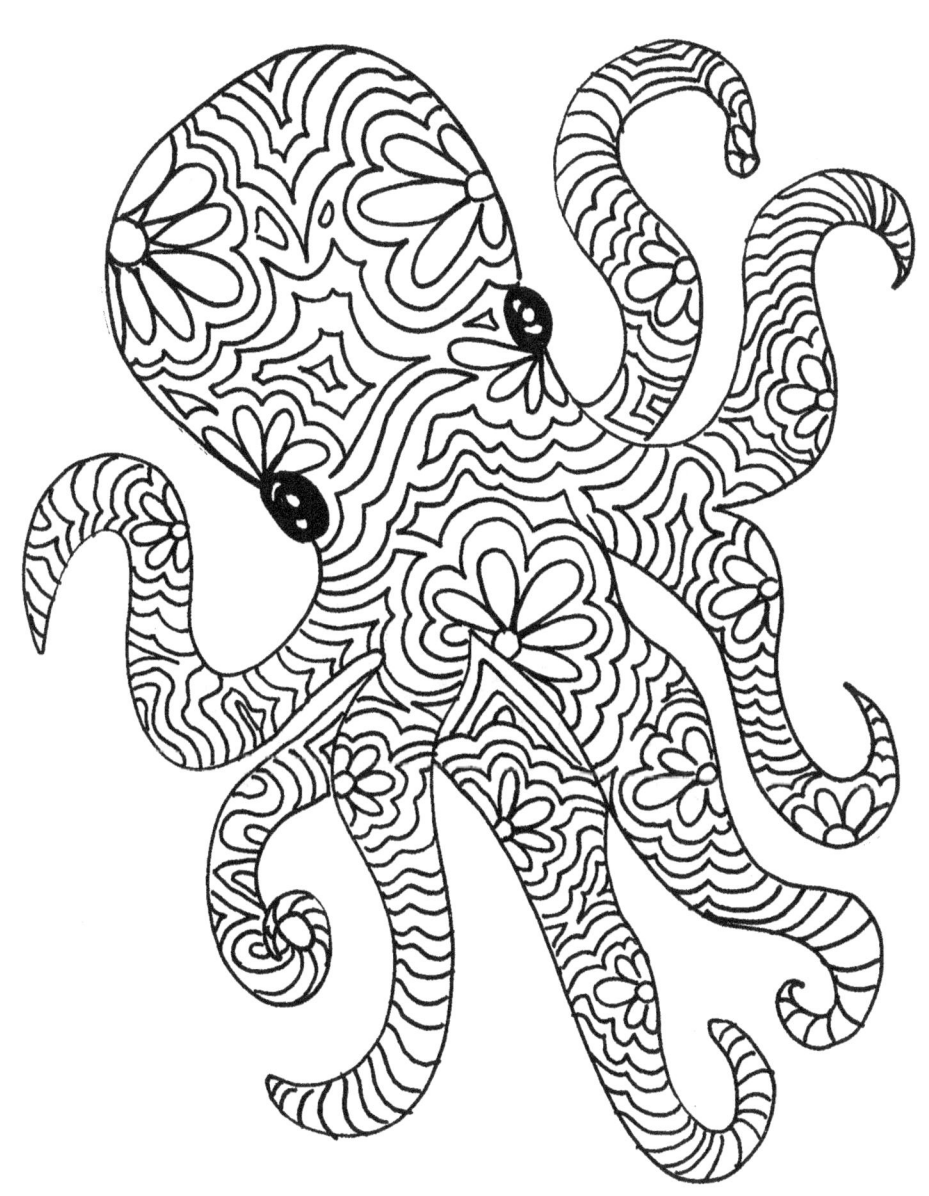

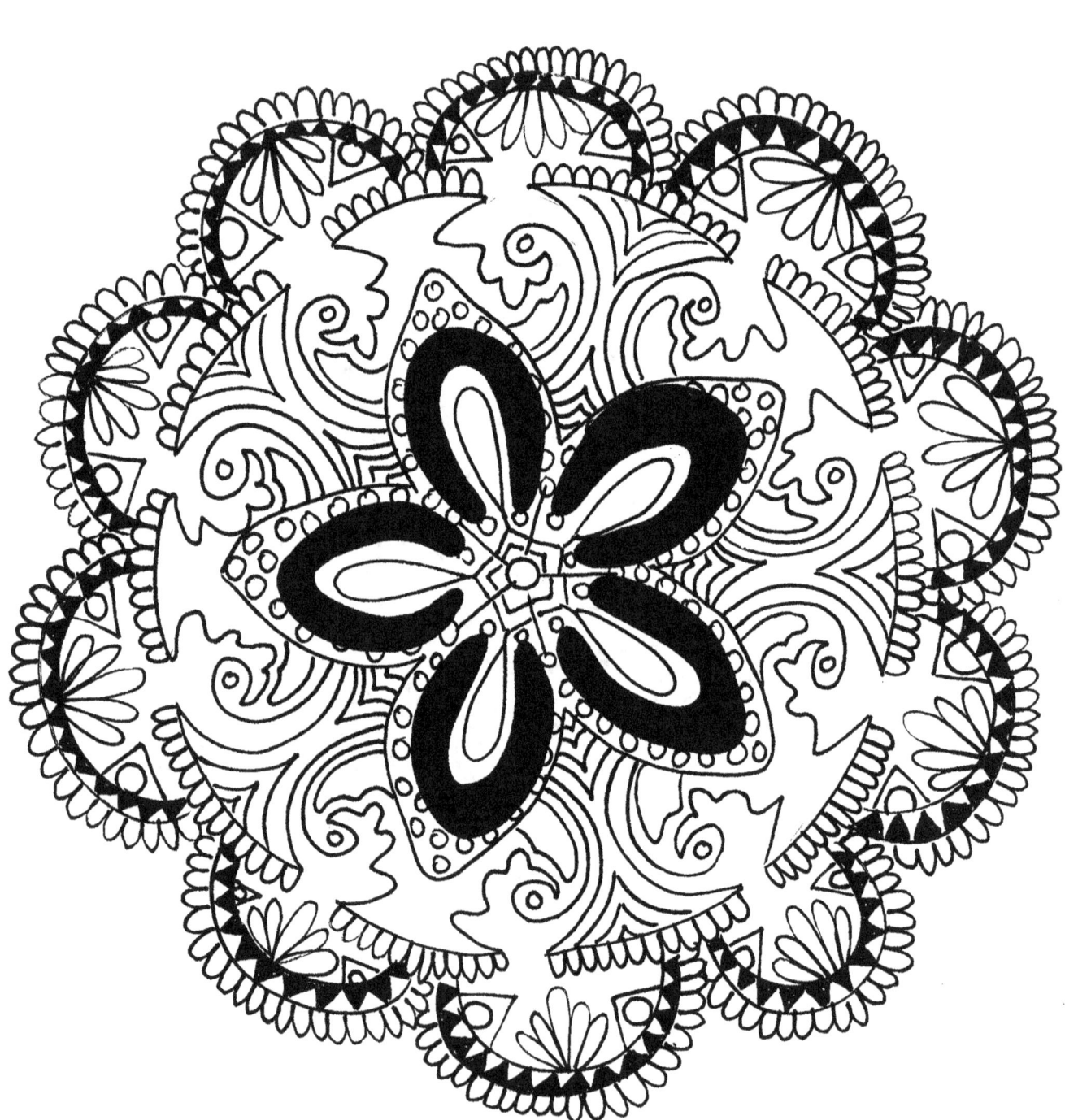

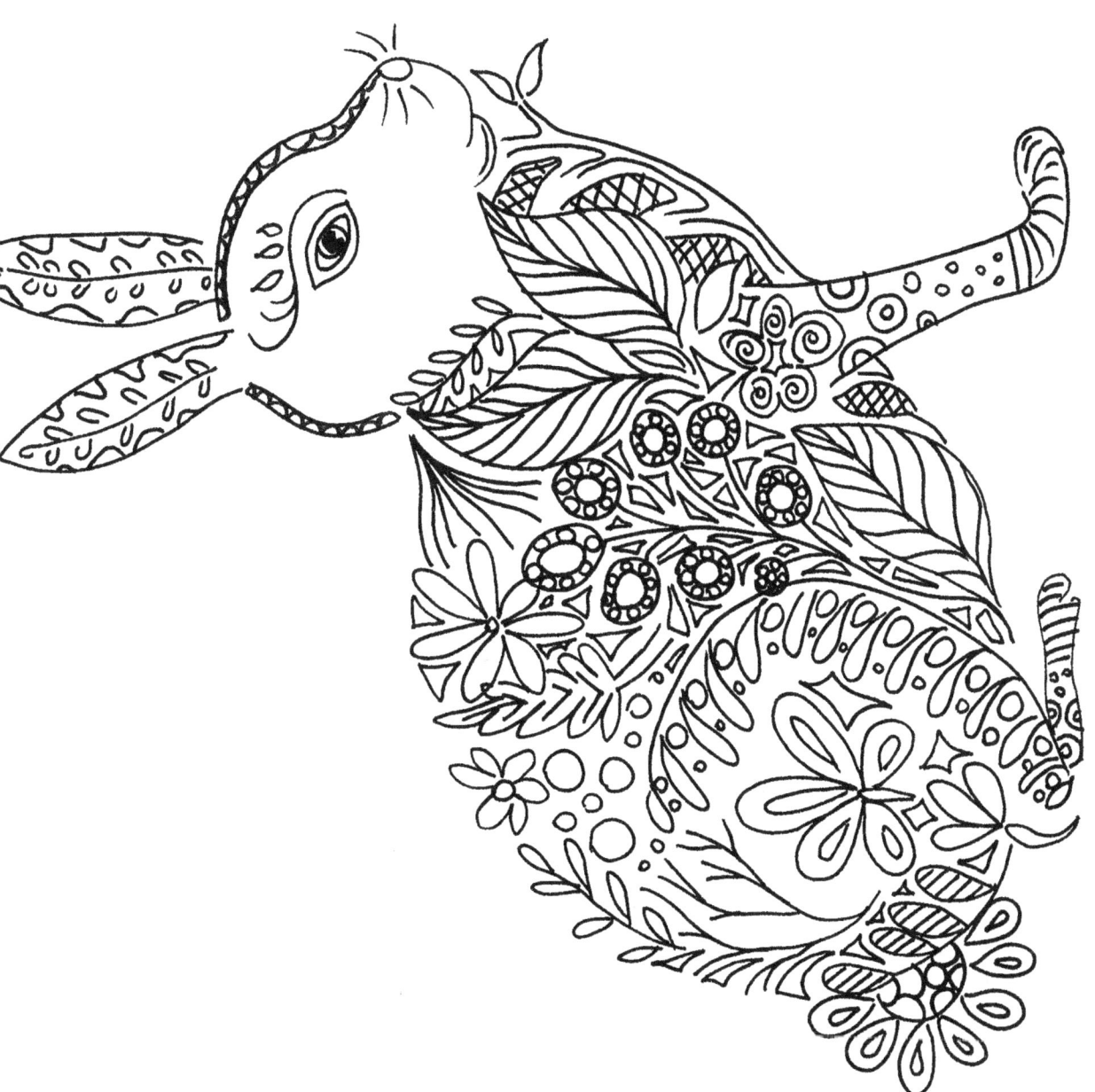

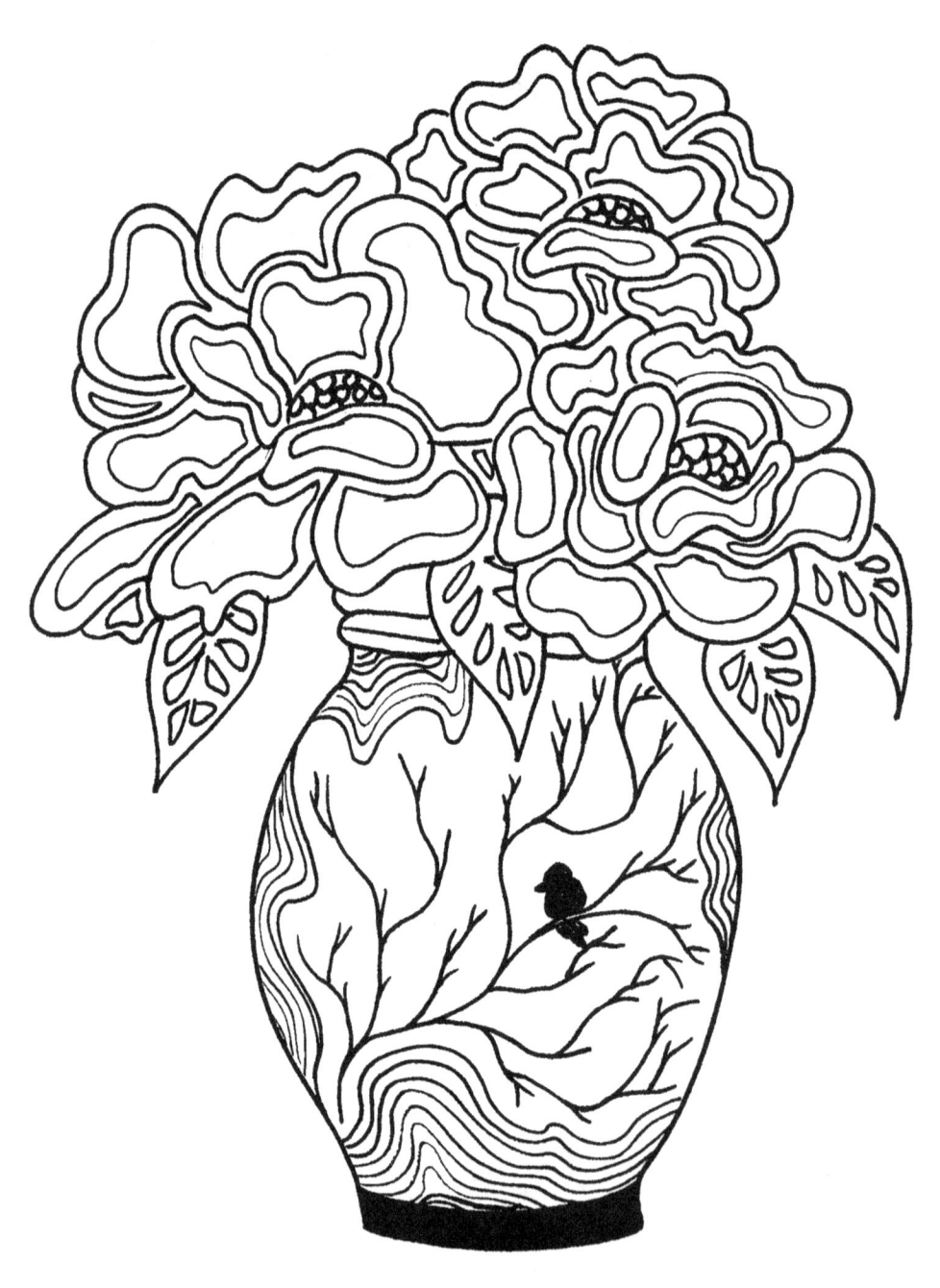

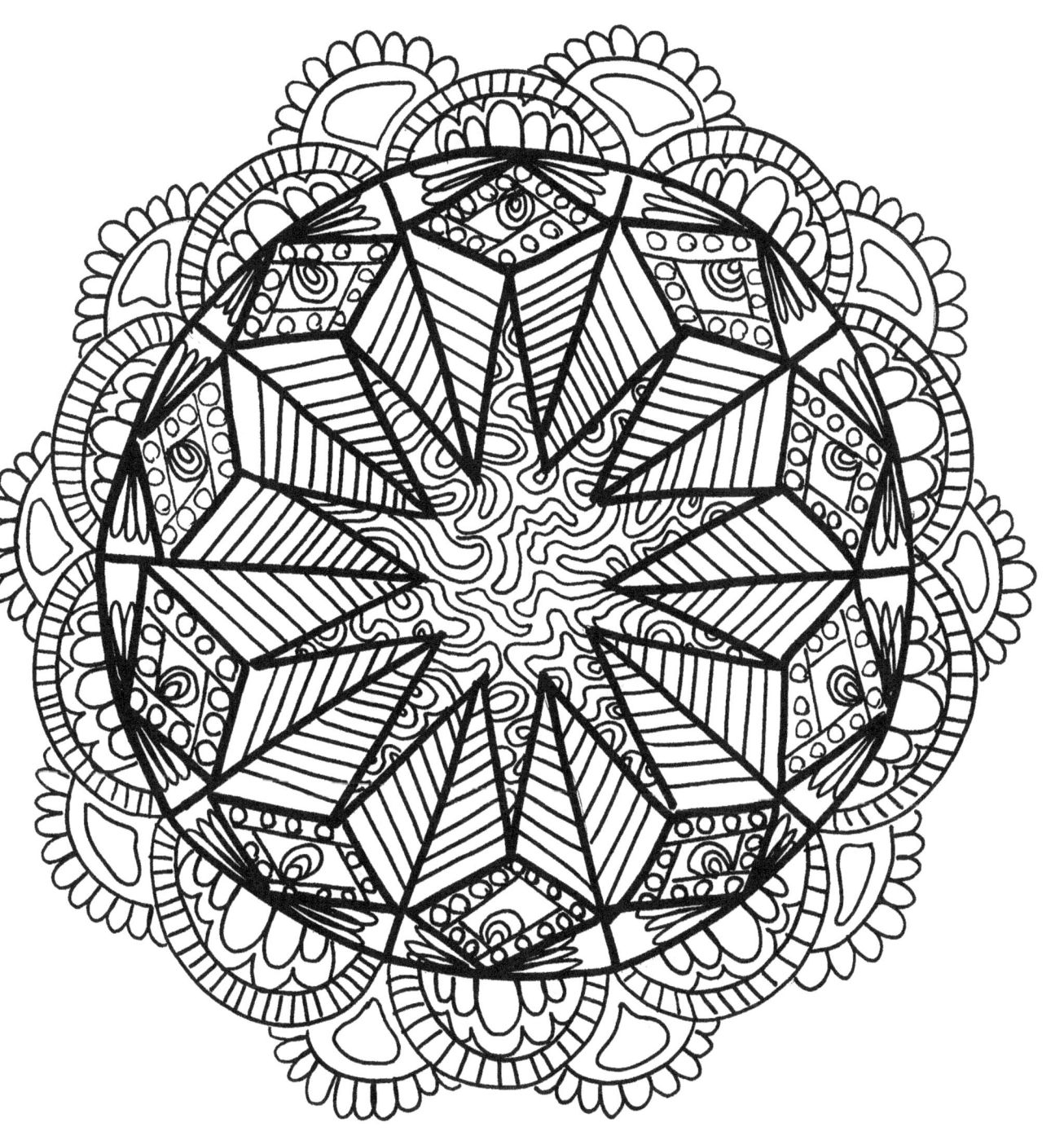

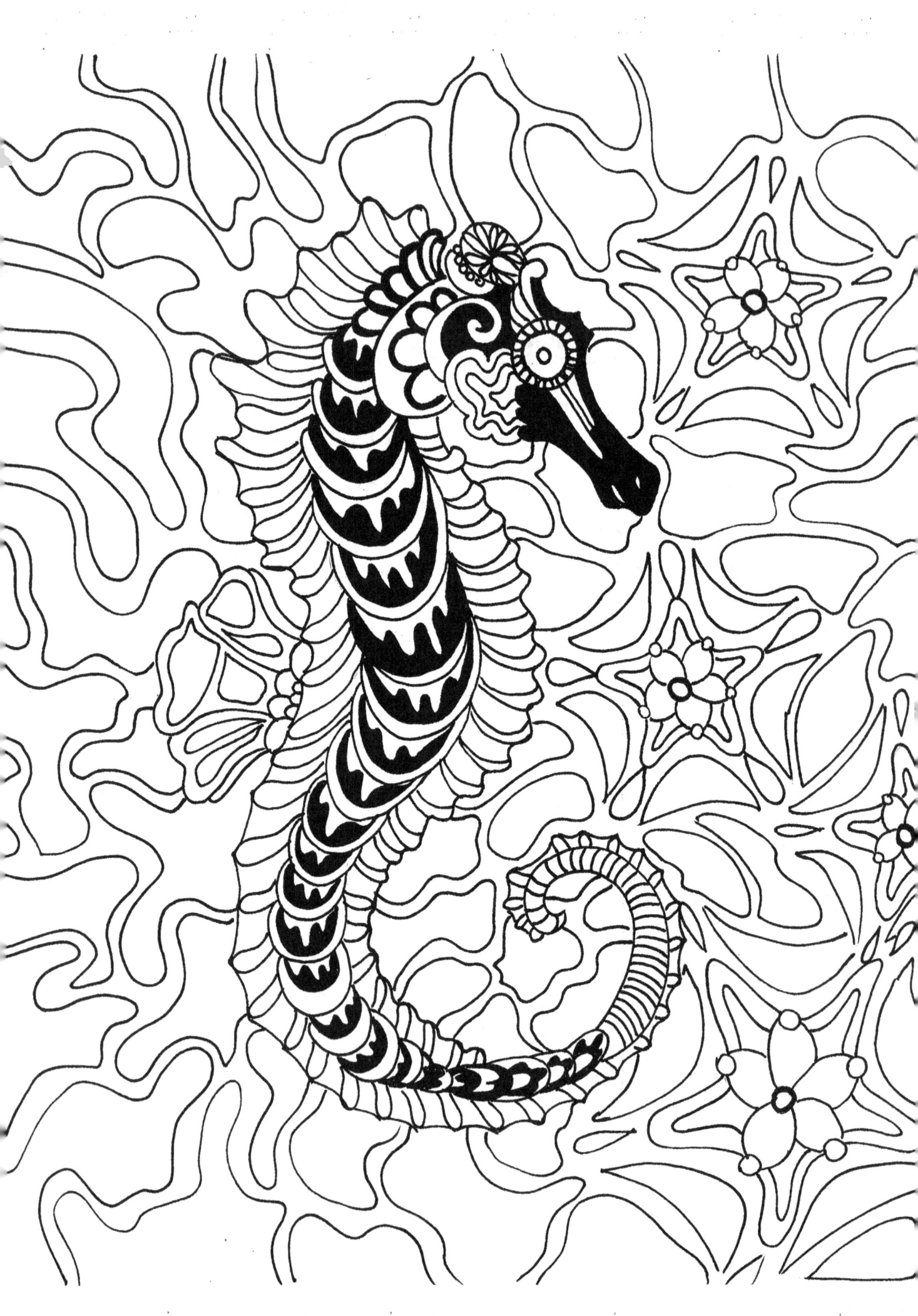

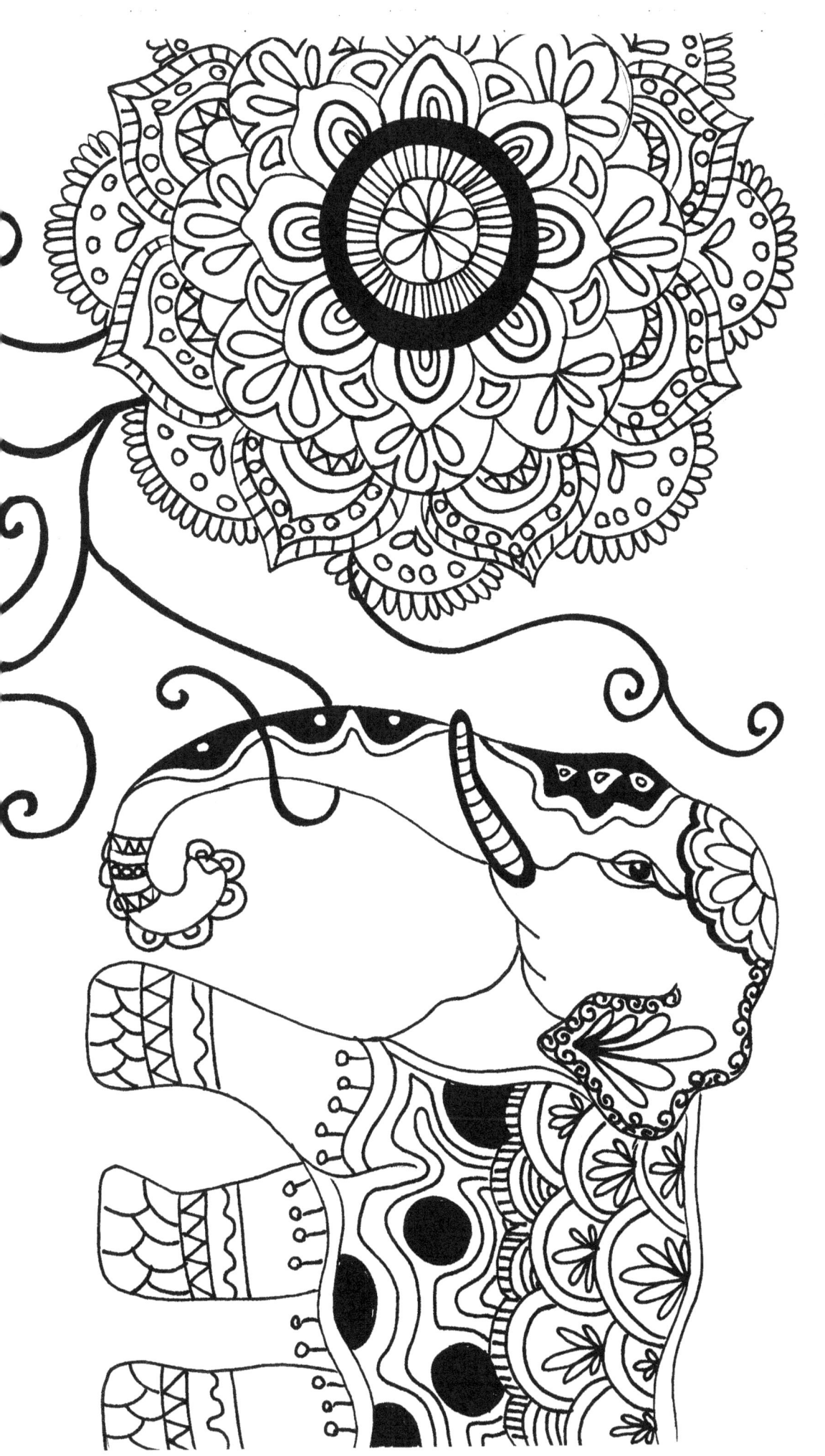

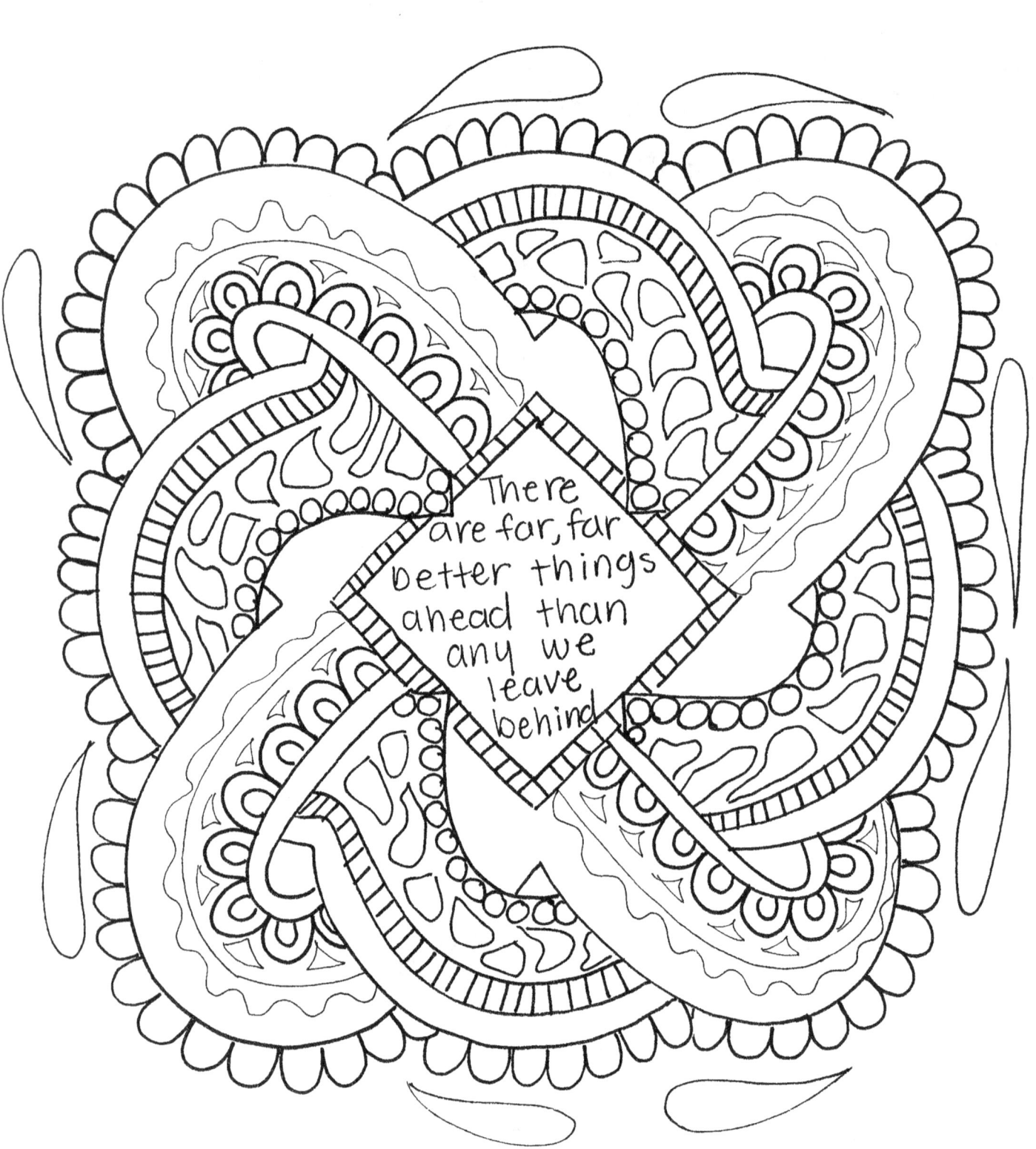

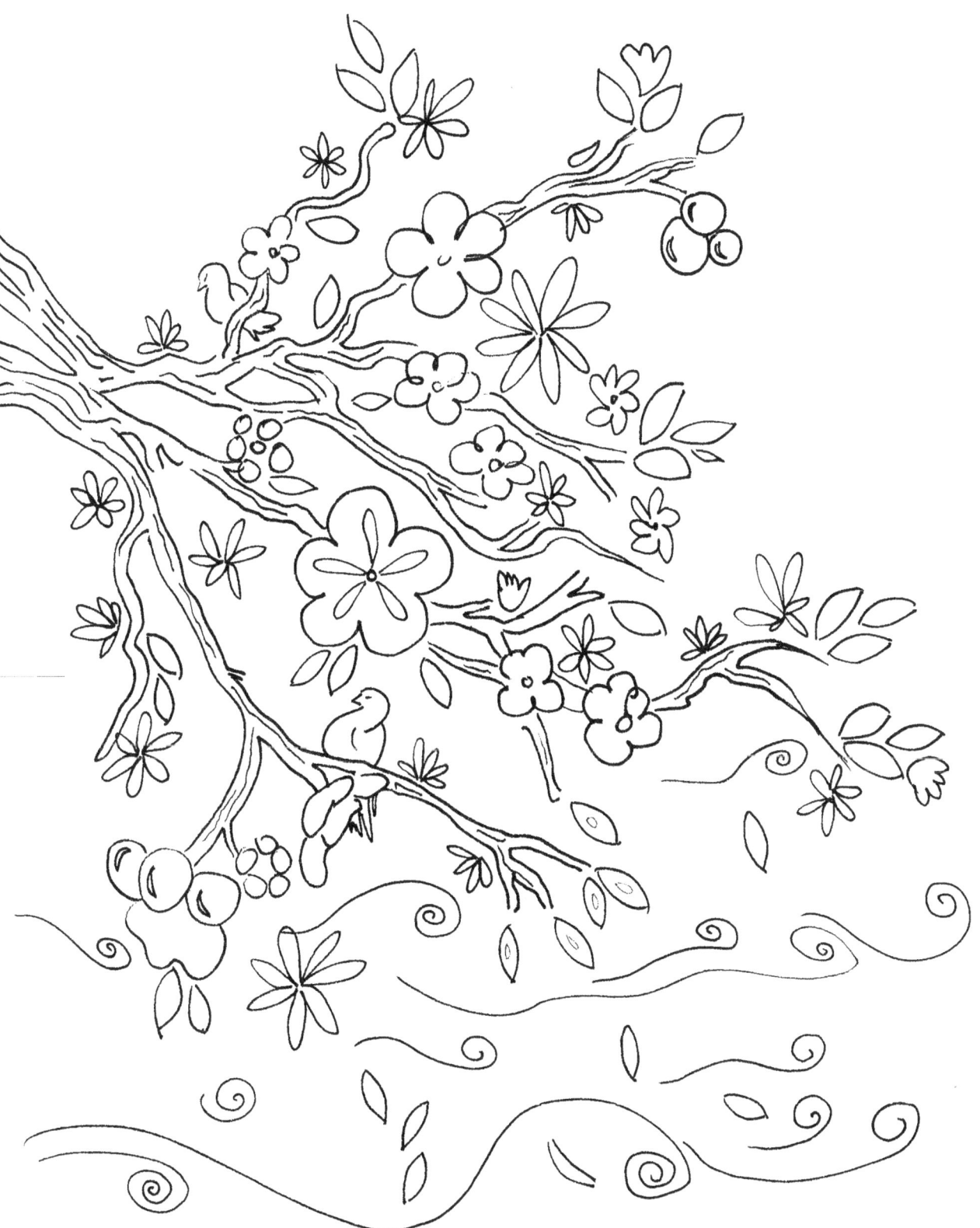

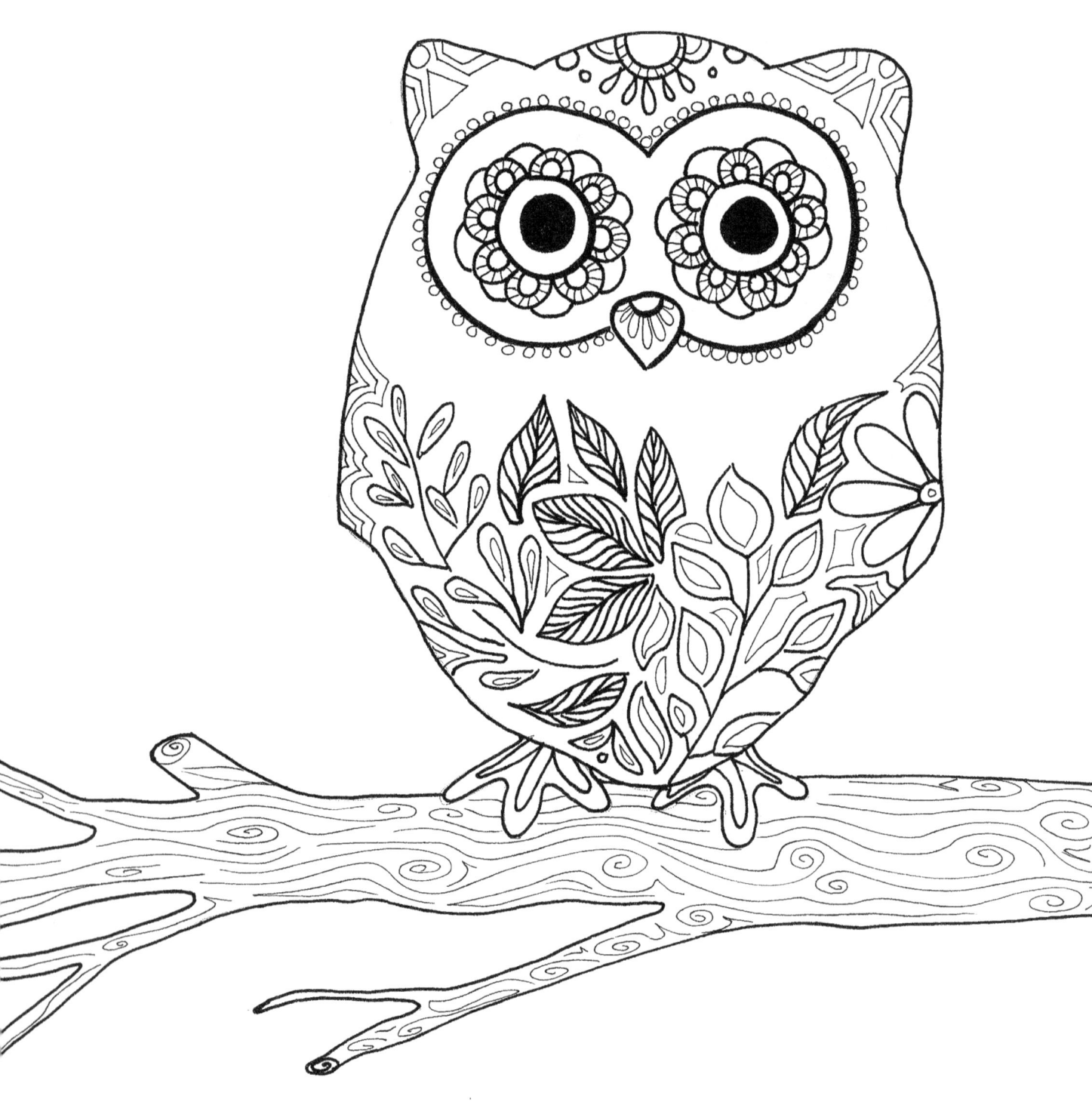

If you get tired,
Learn to rest,
Not quit.

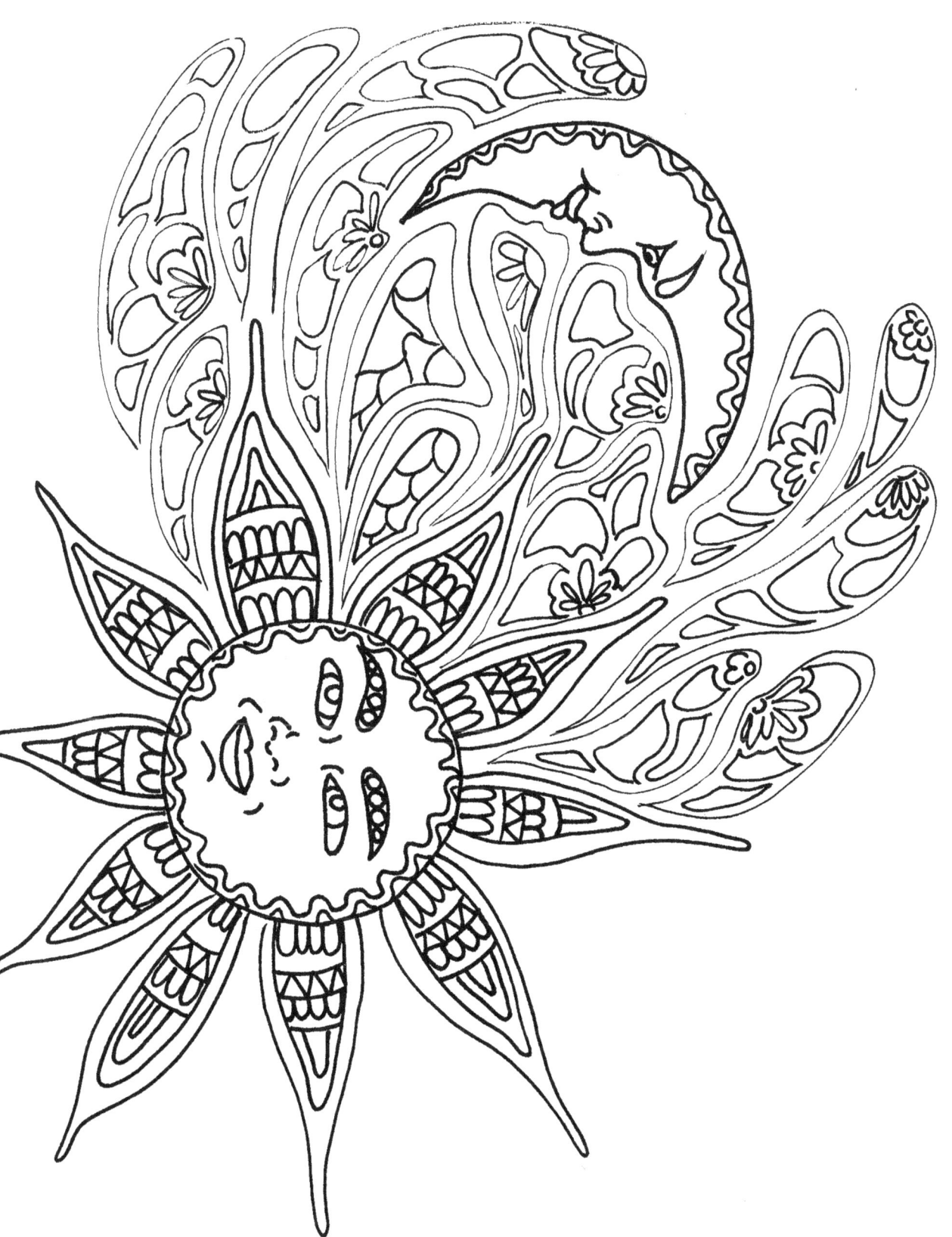

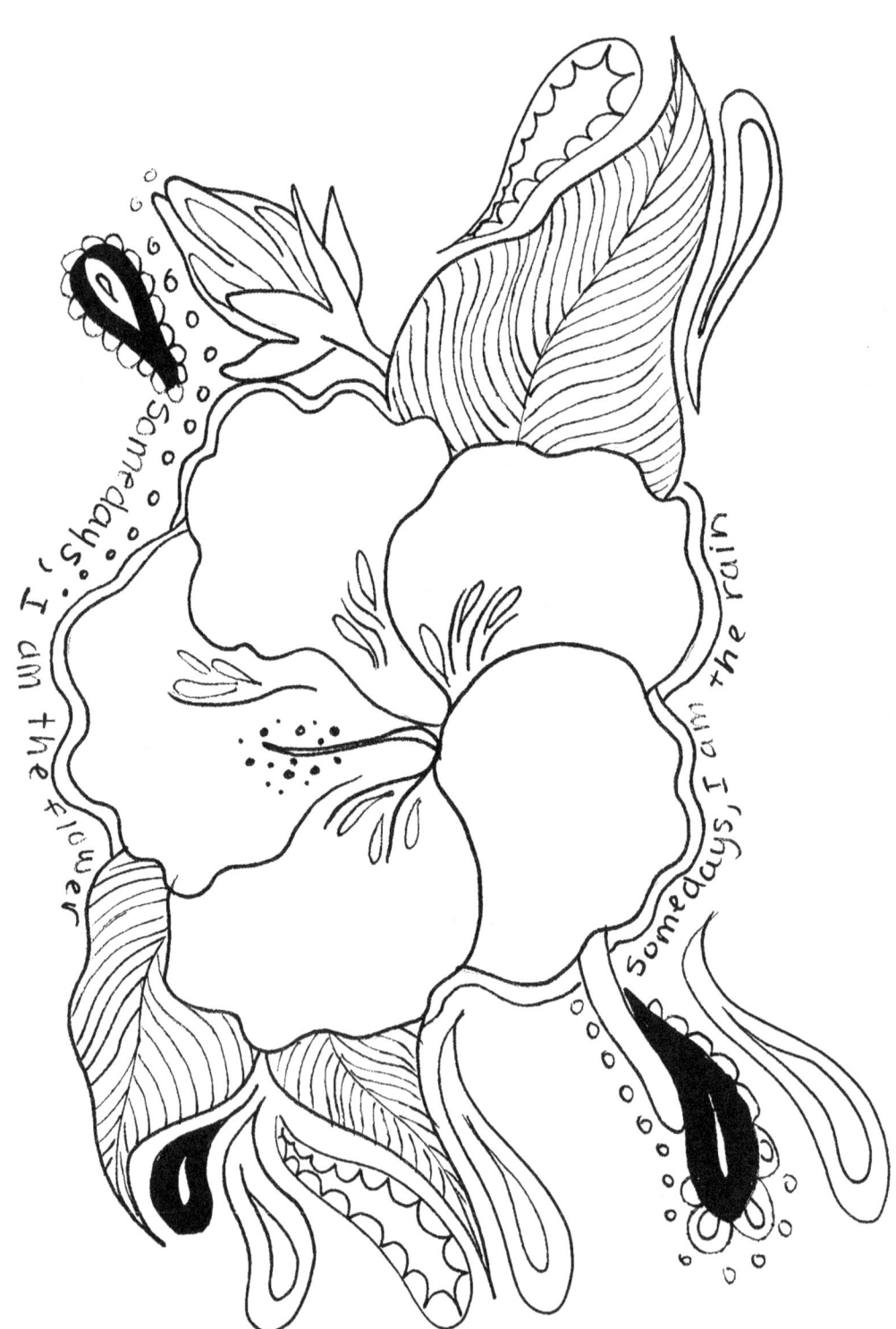

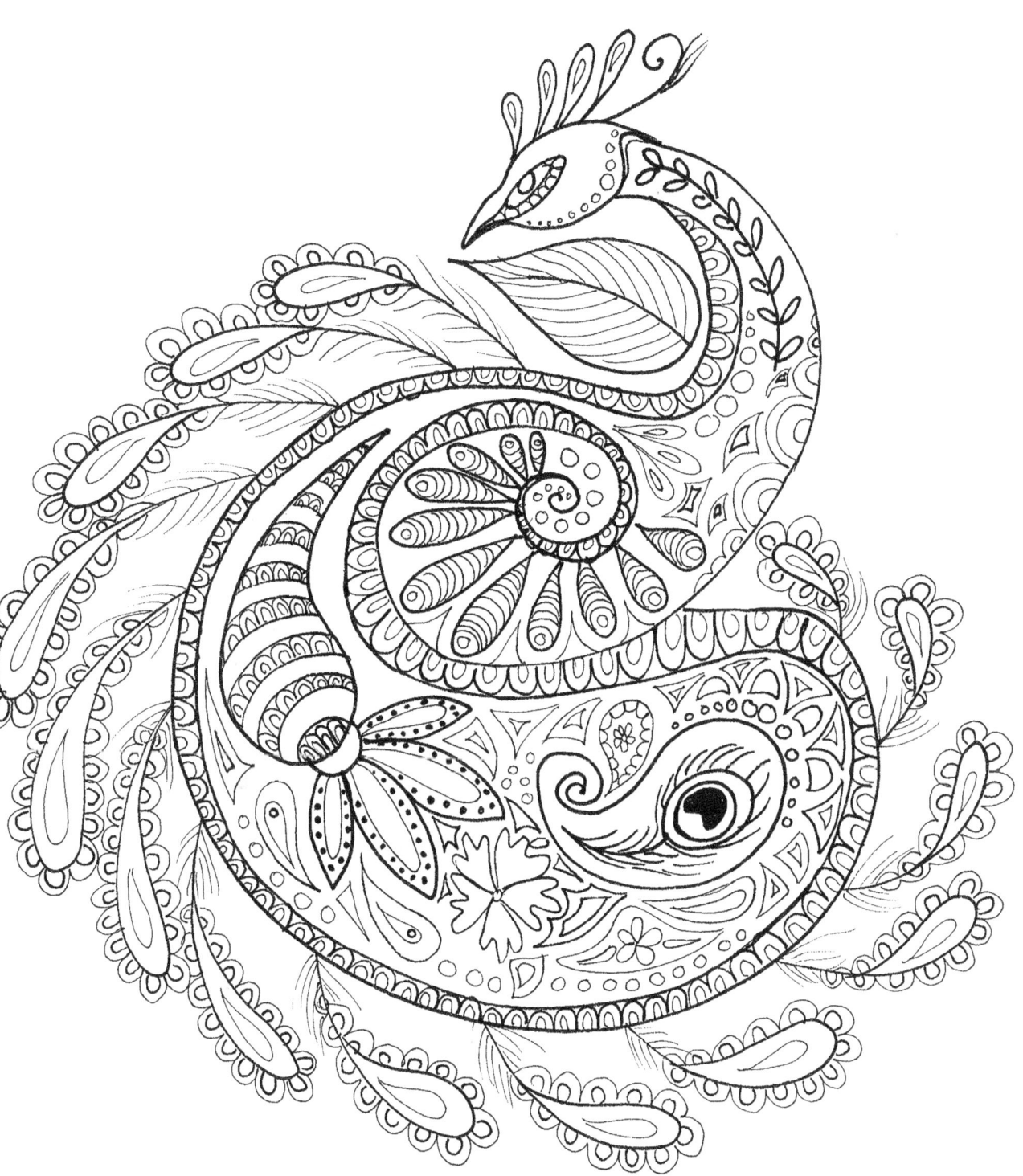

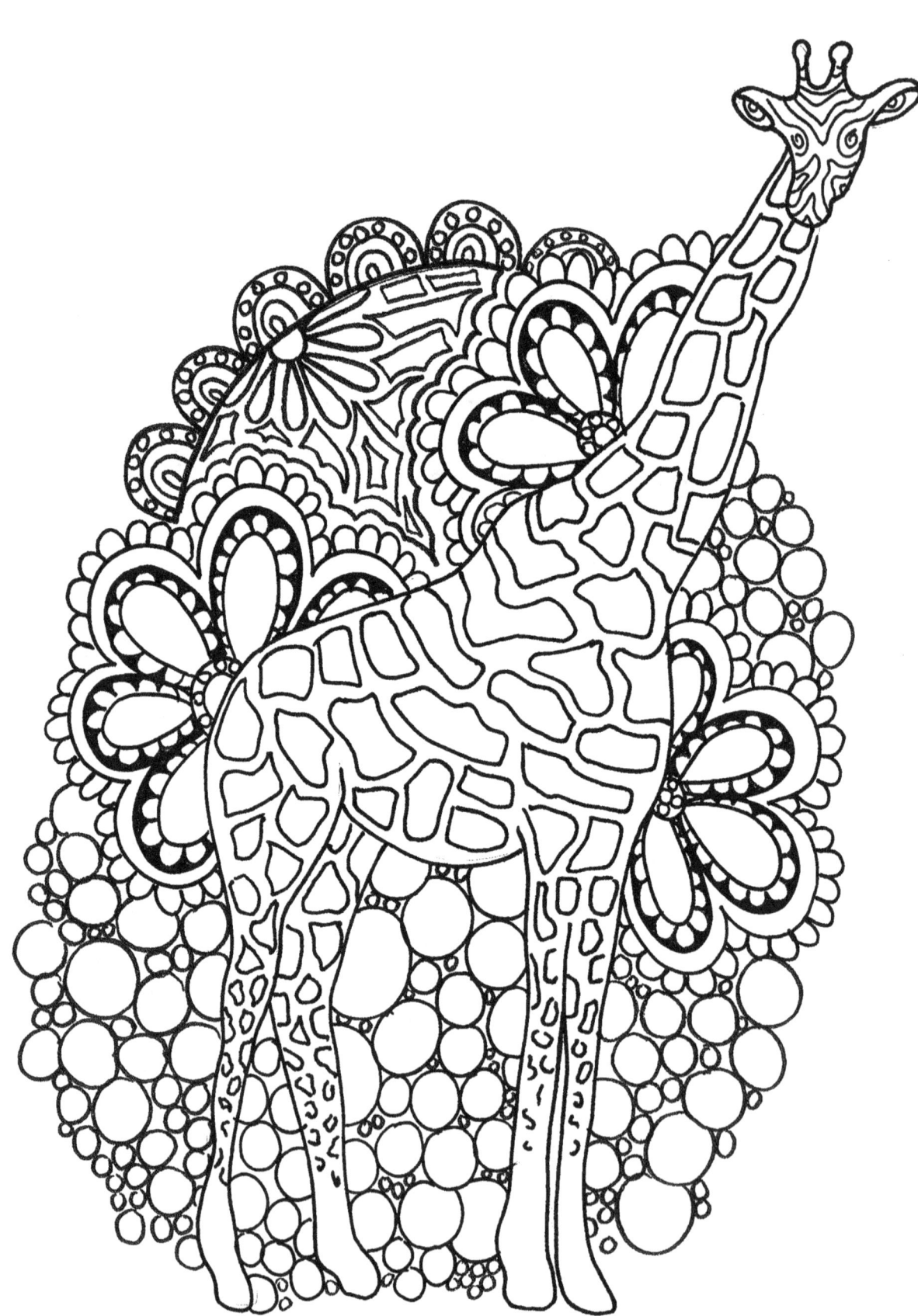

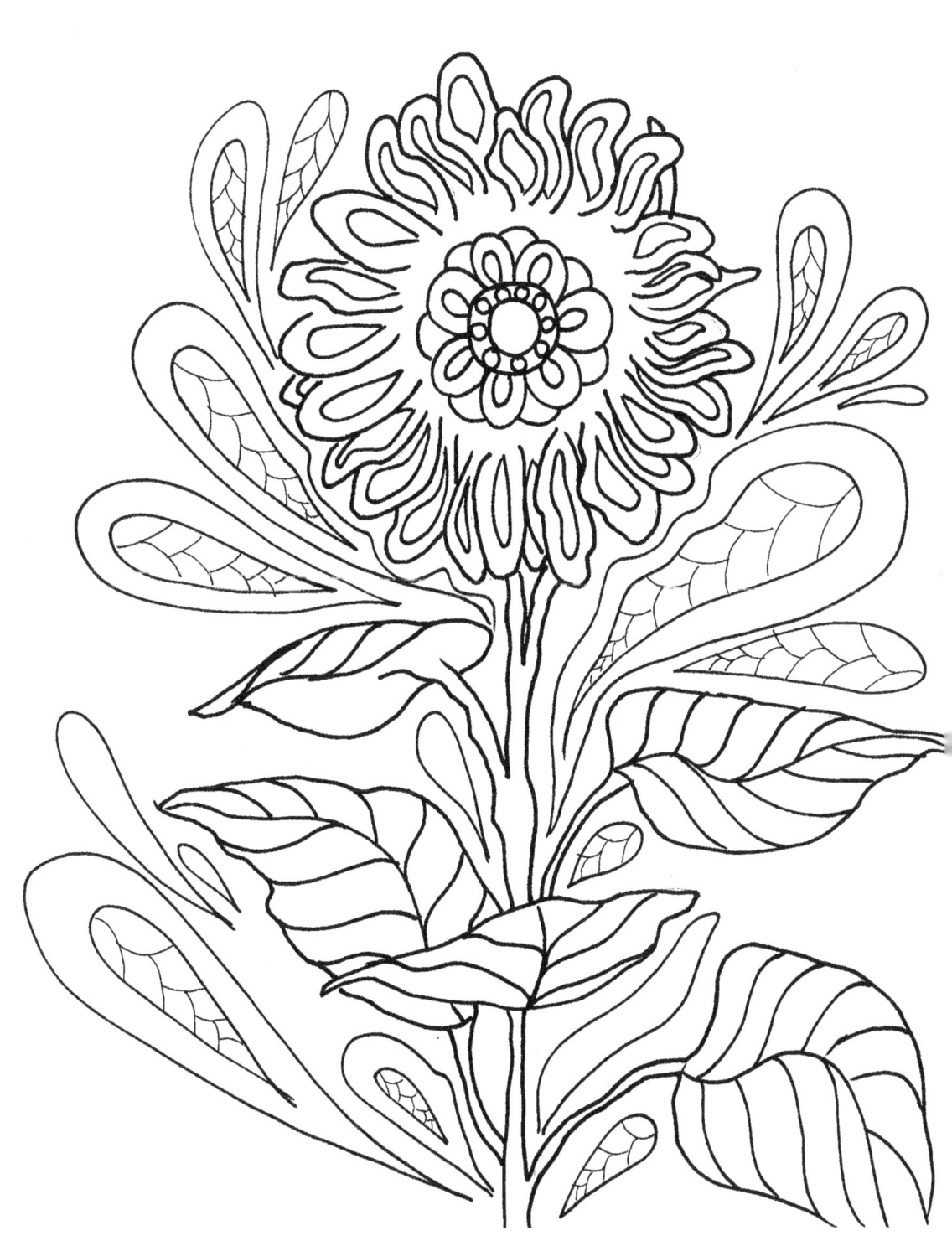

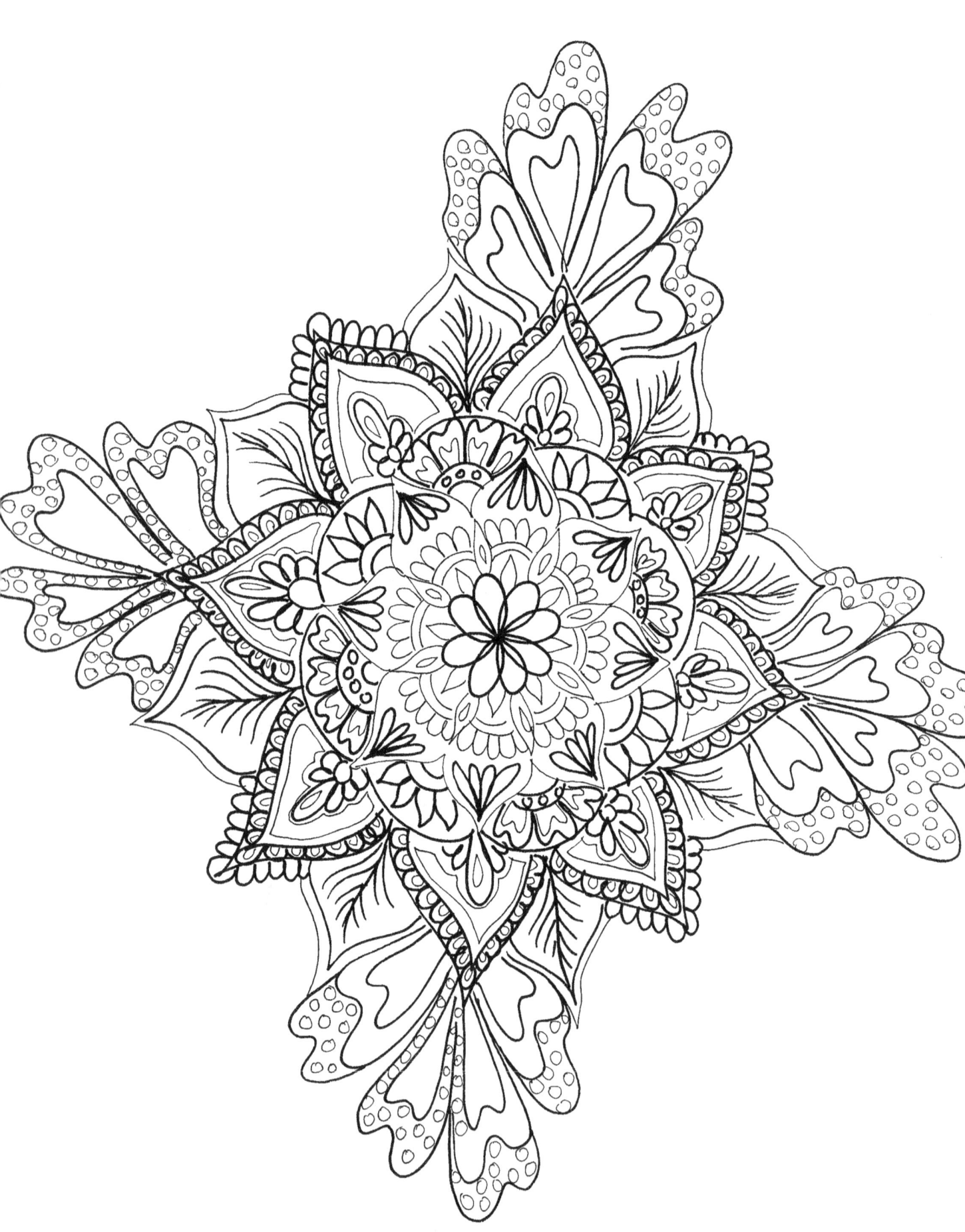

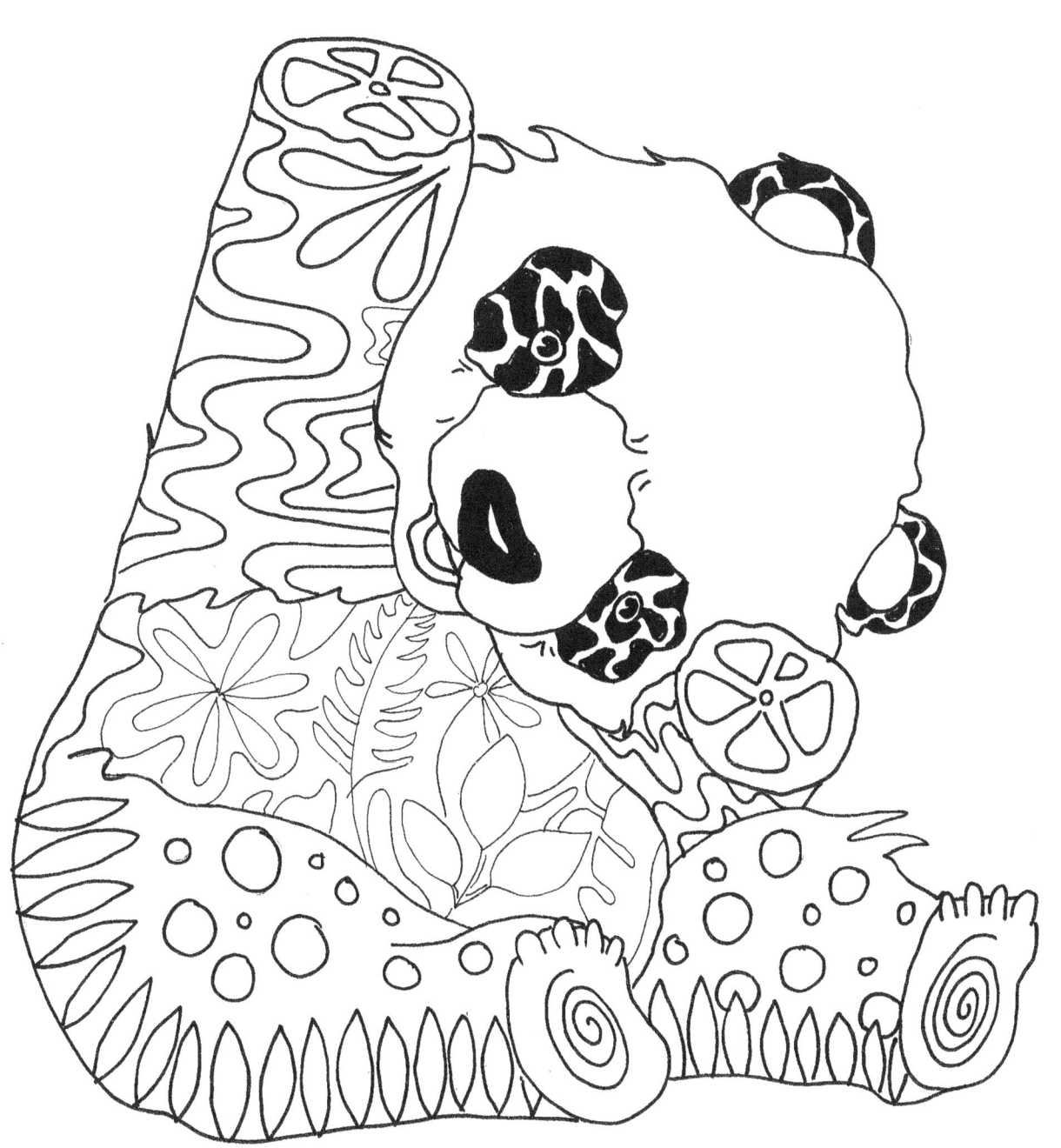

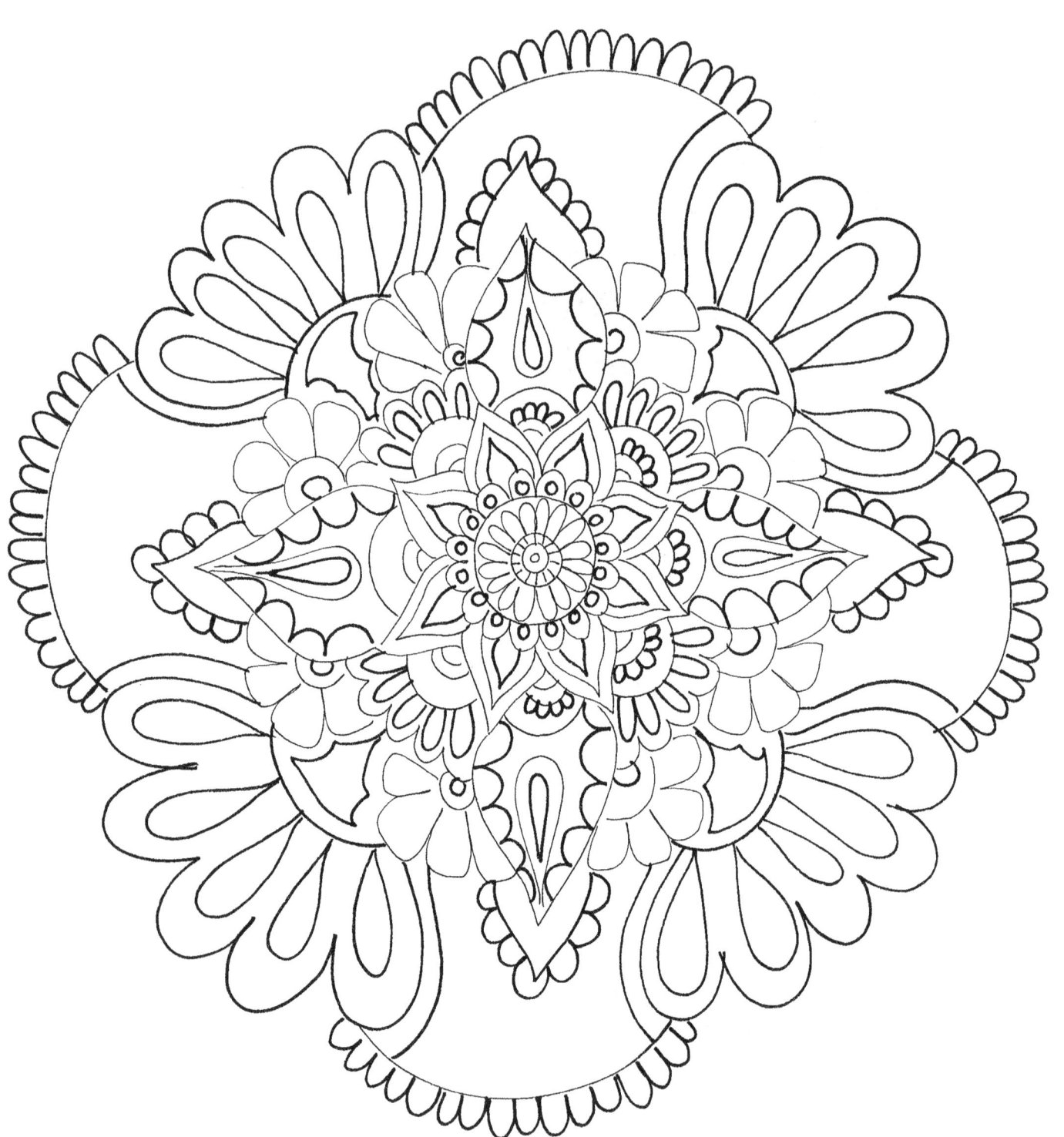

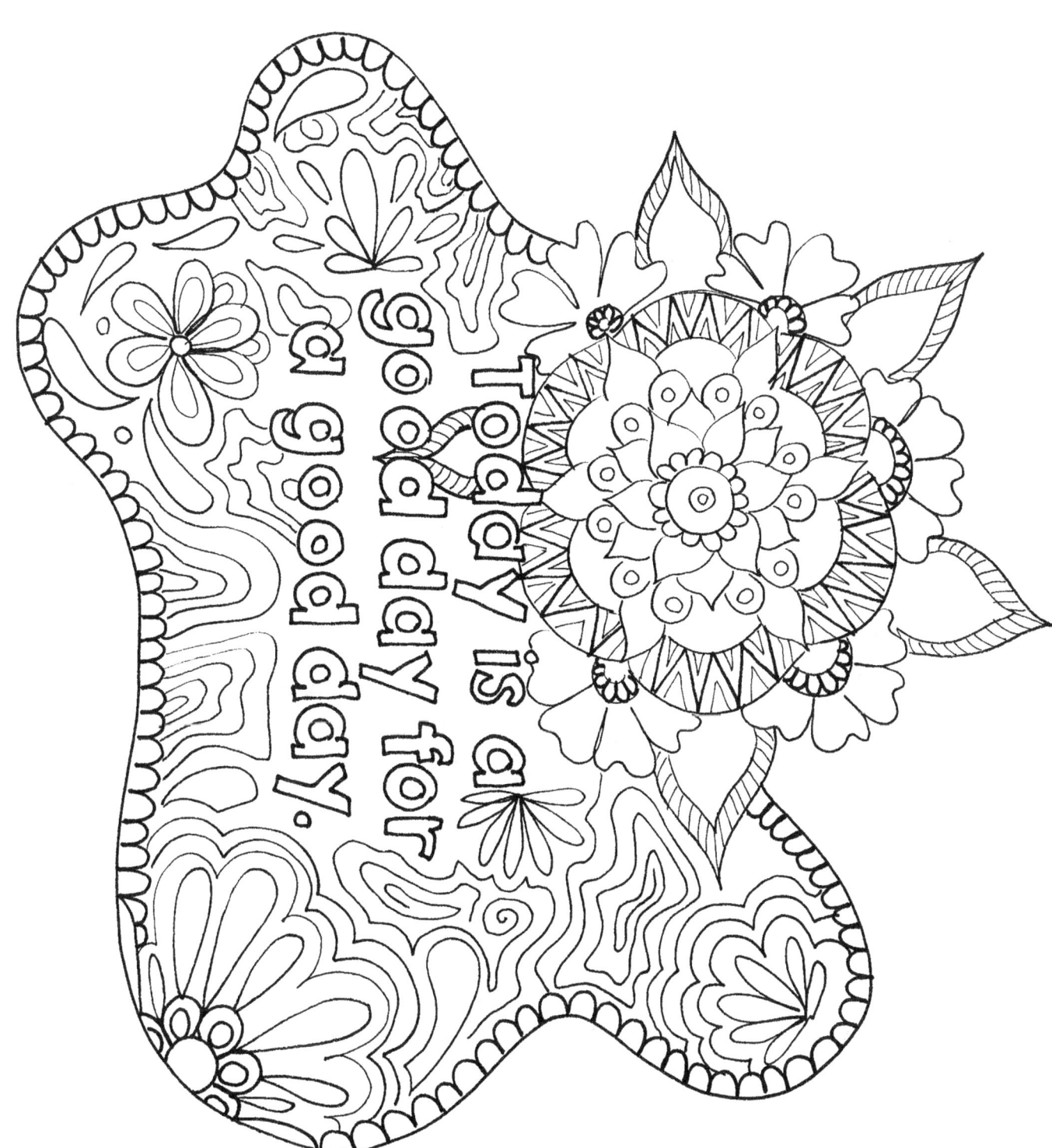

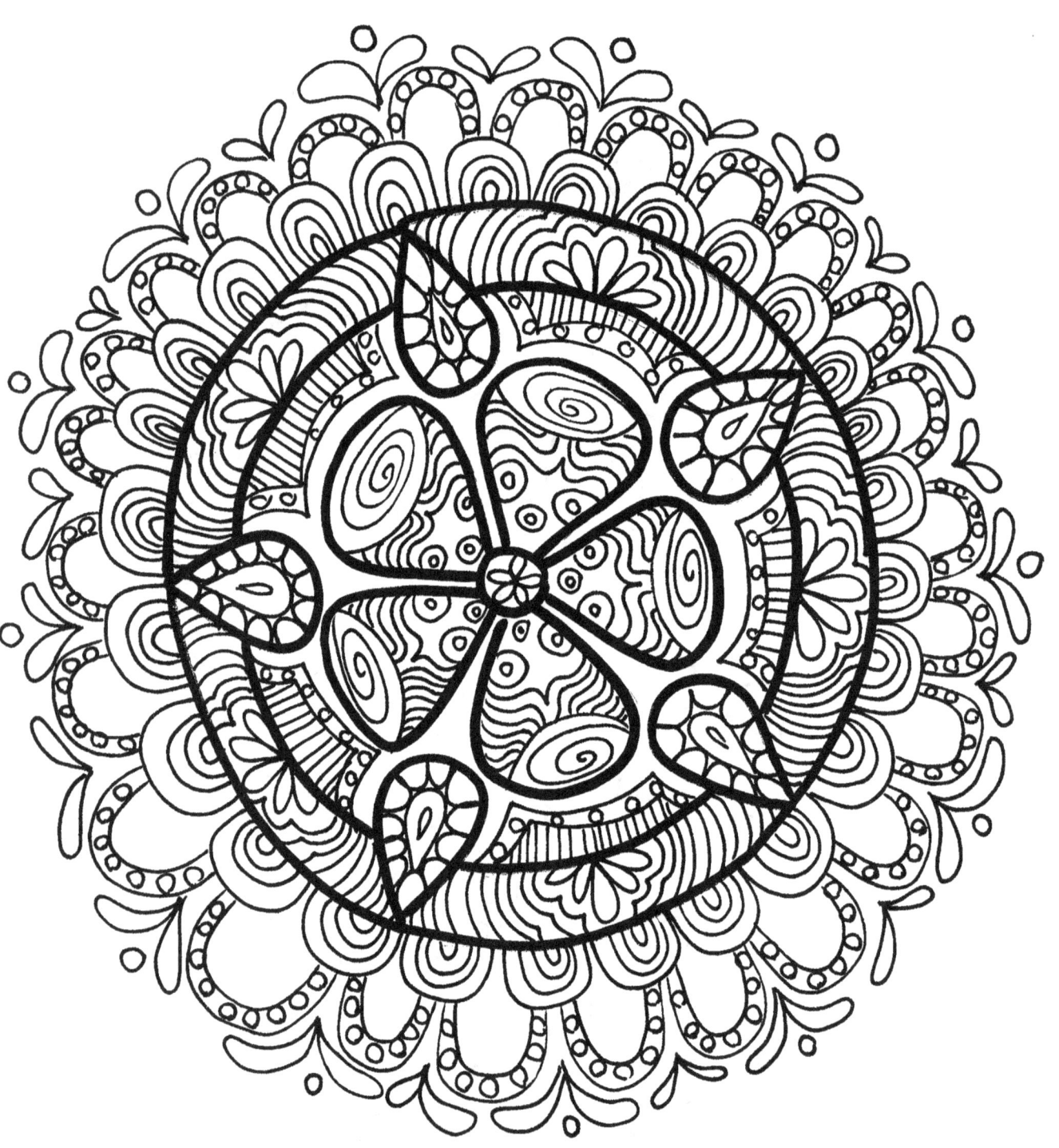

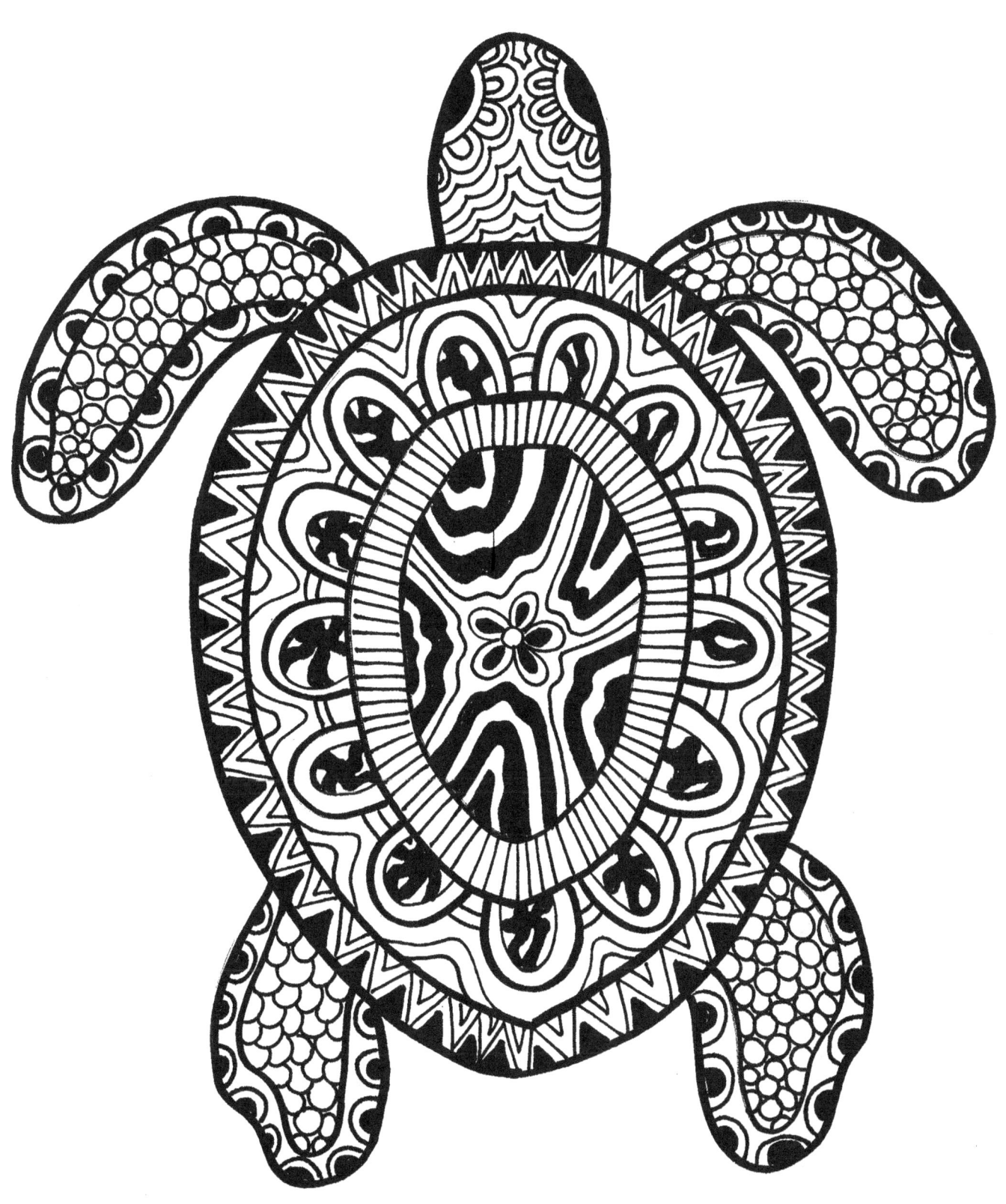

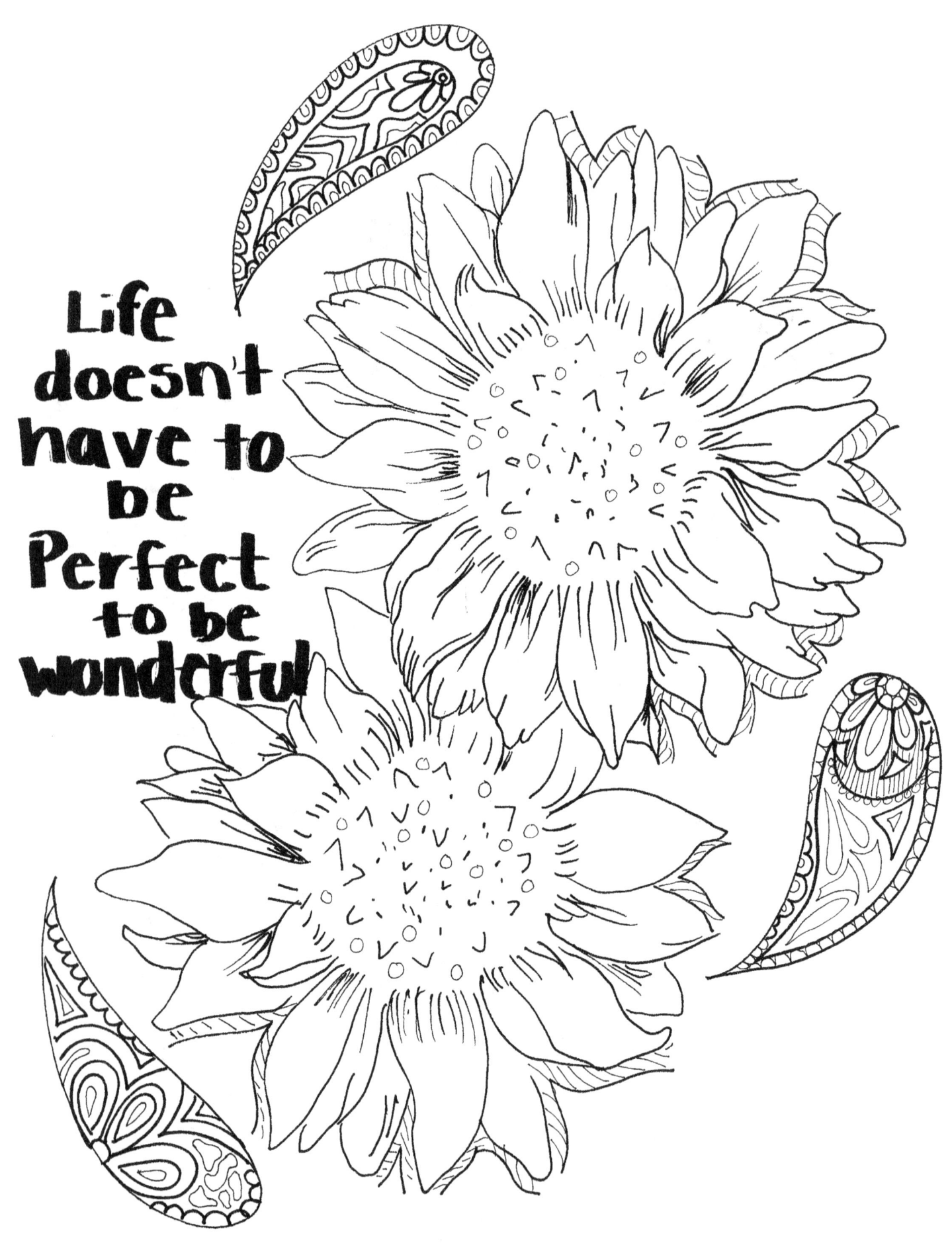

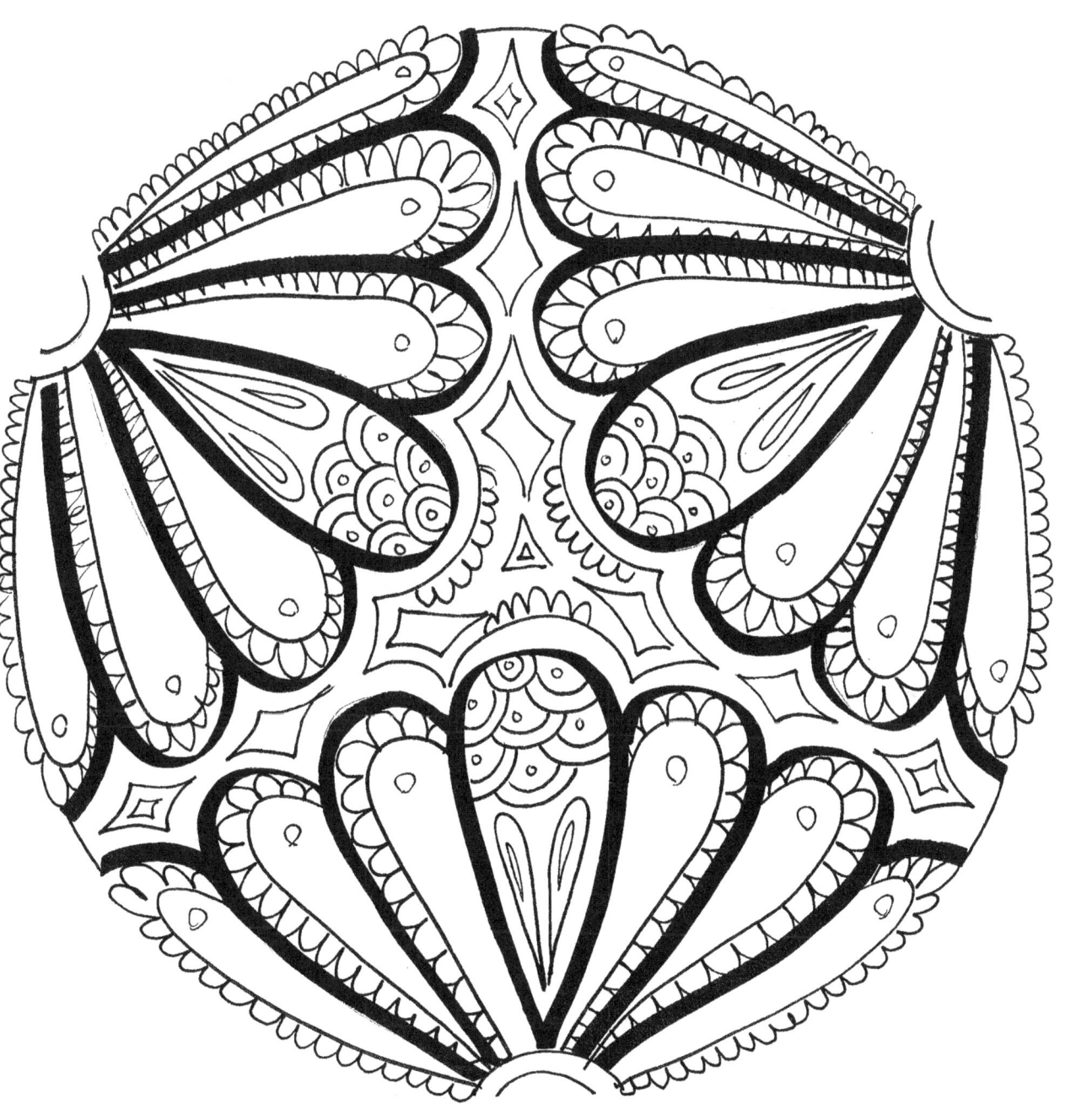

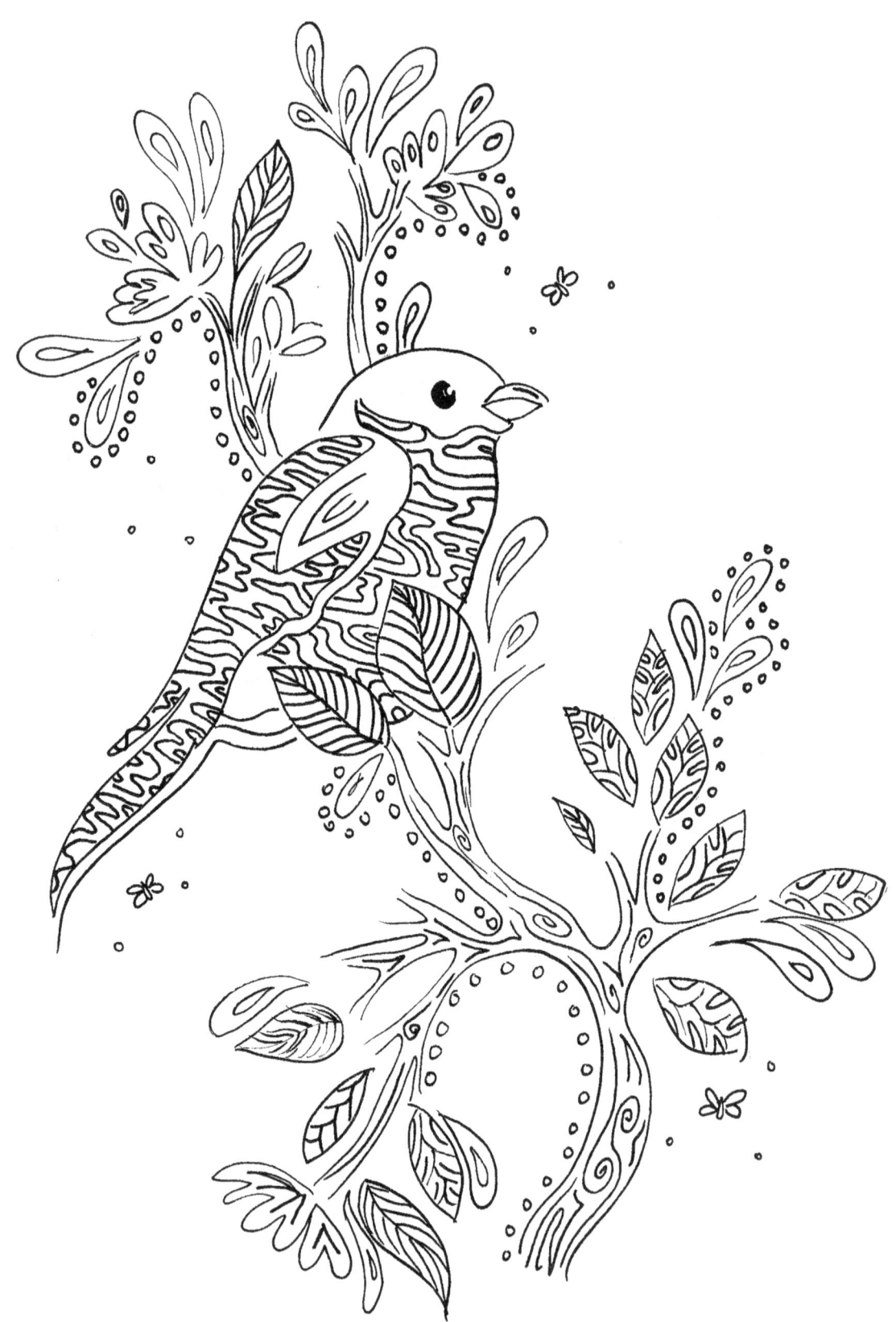

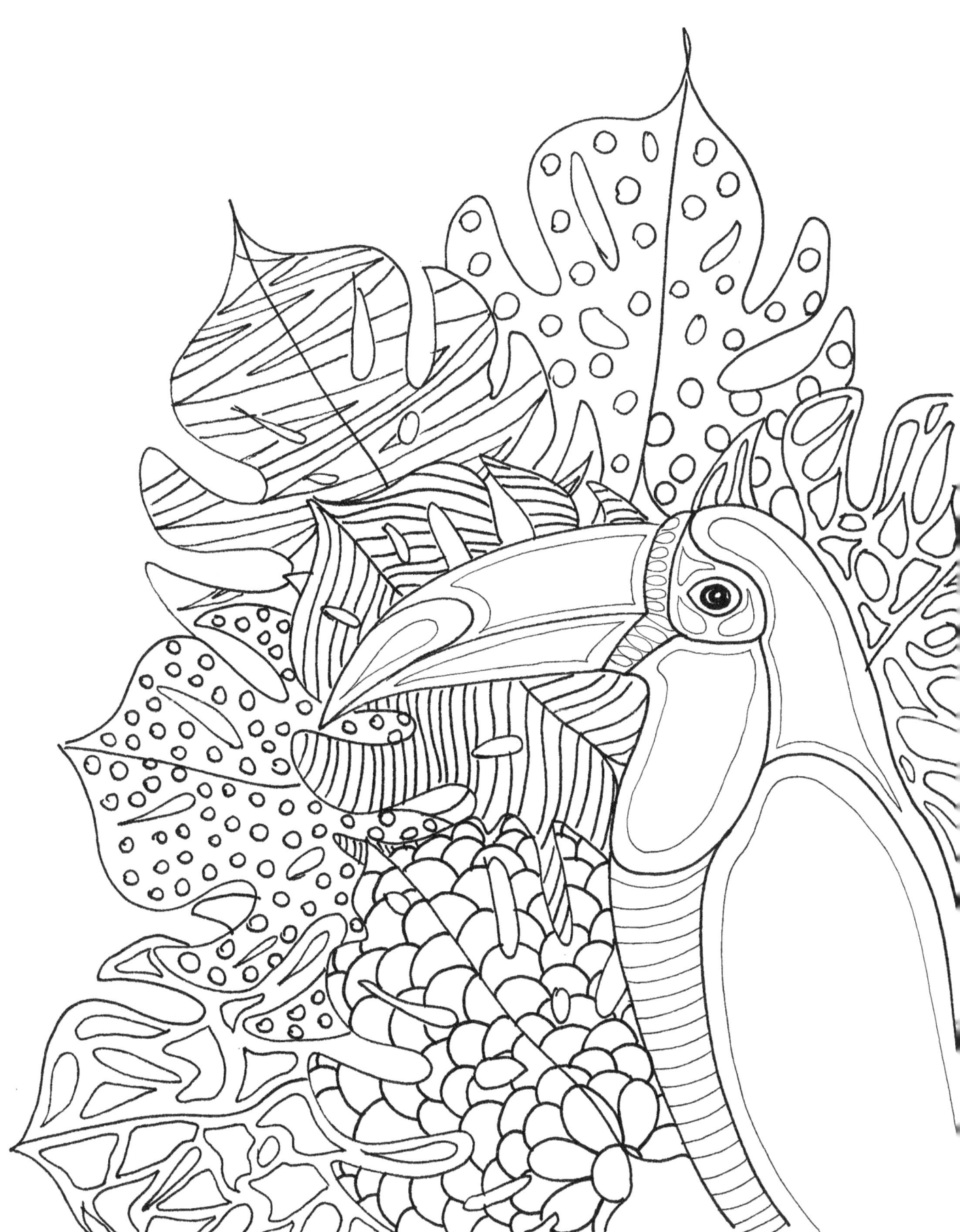

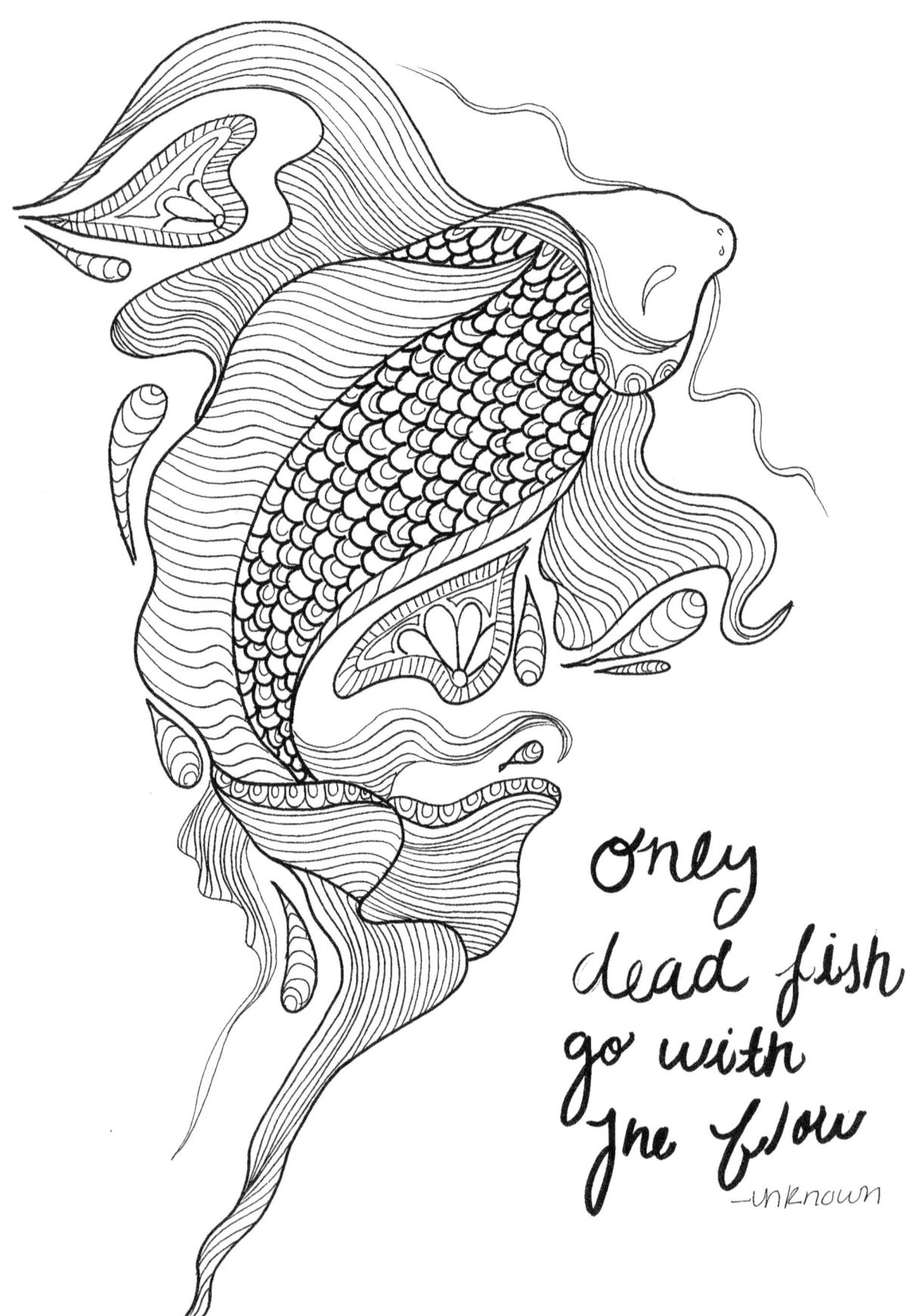

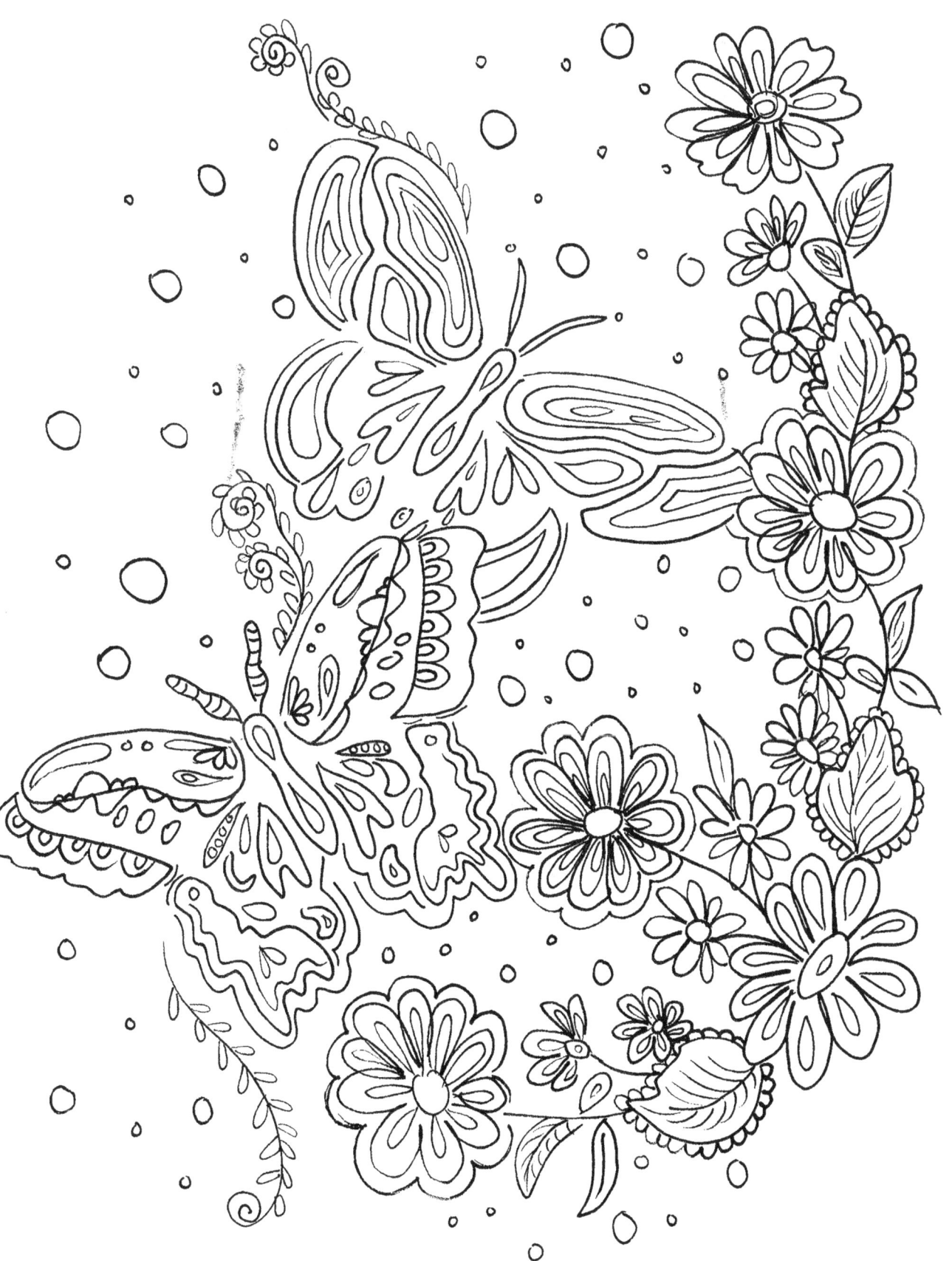

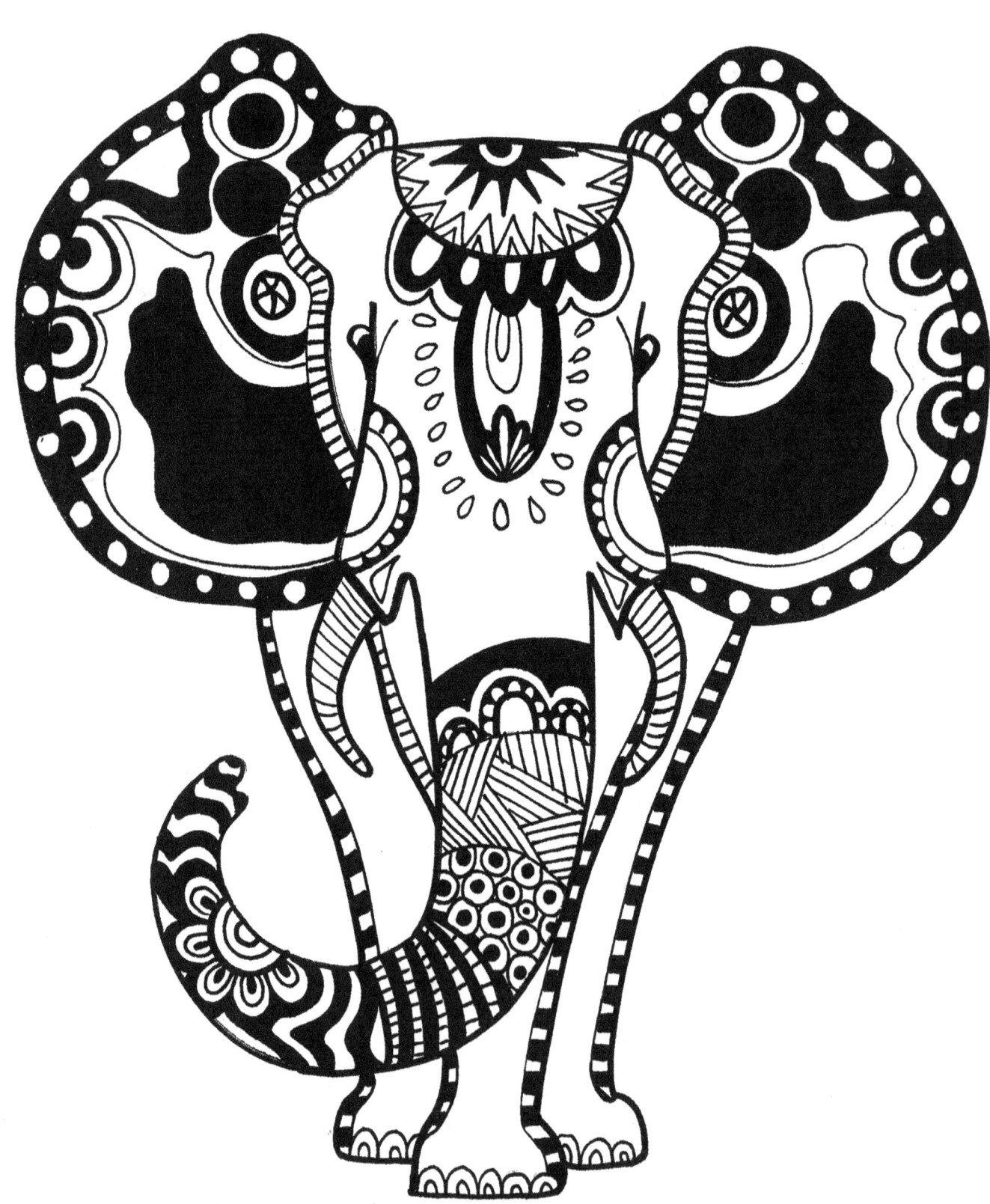

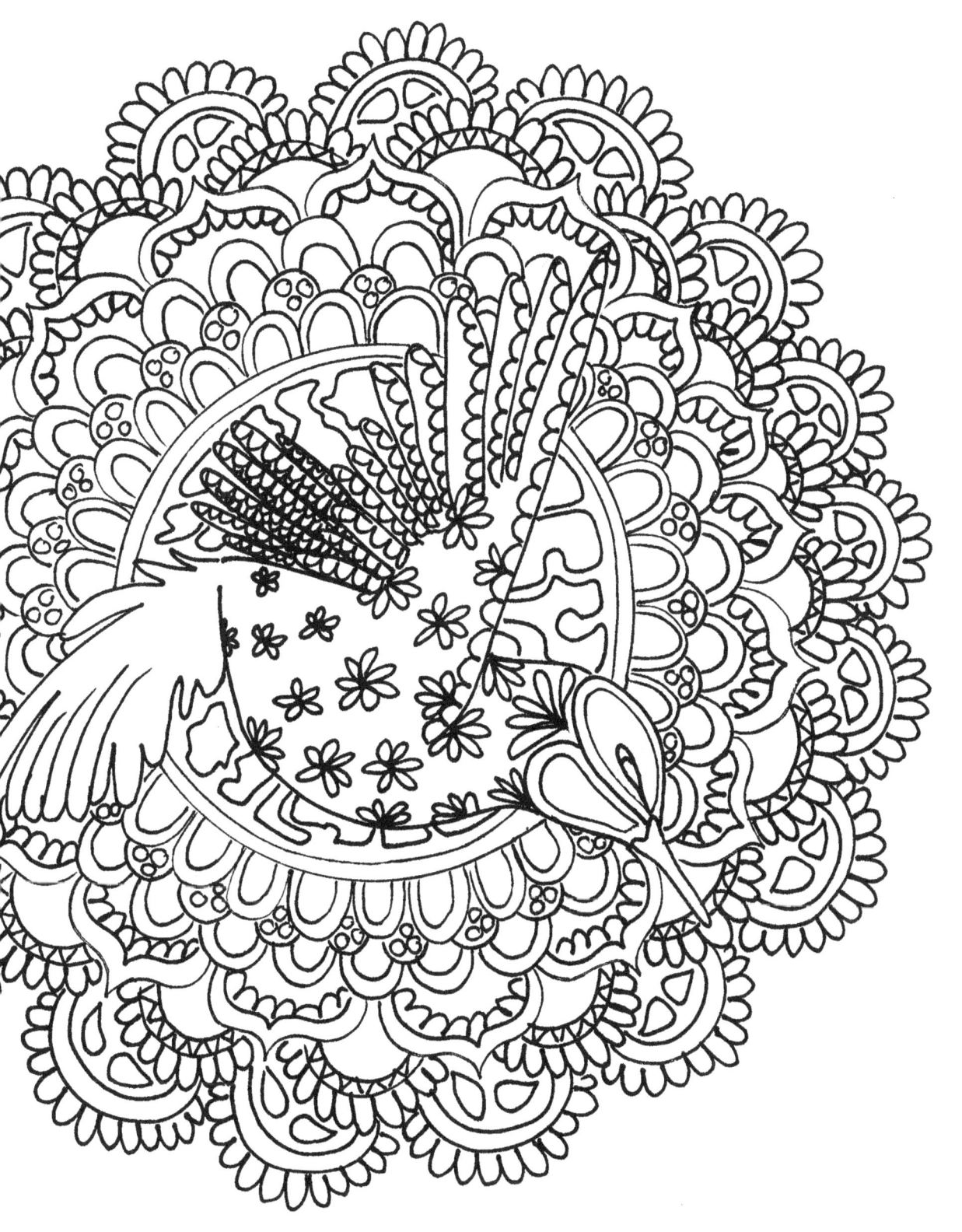

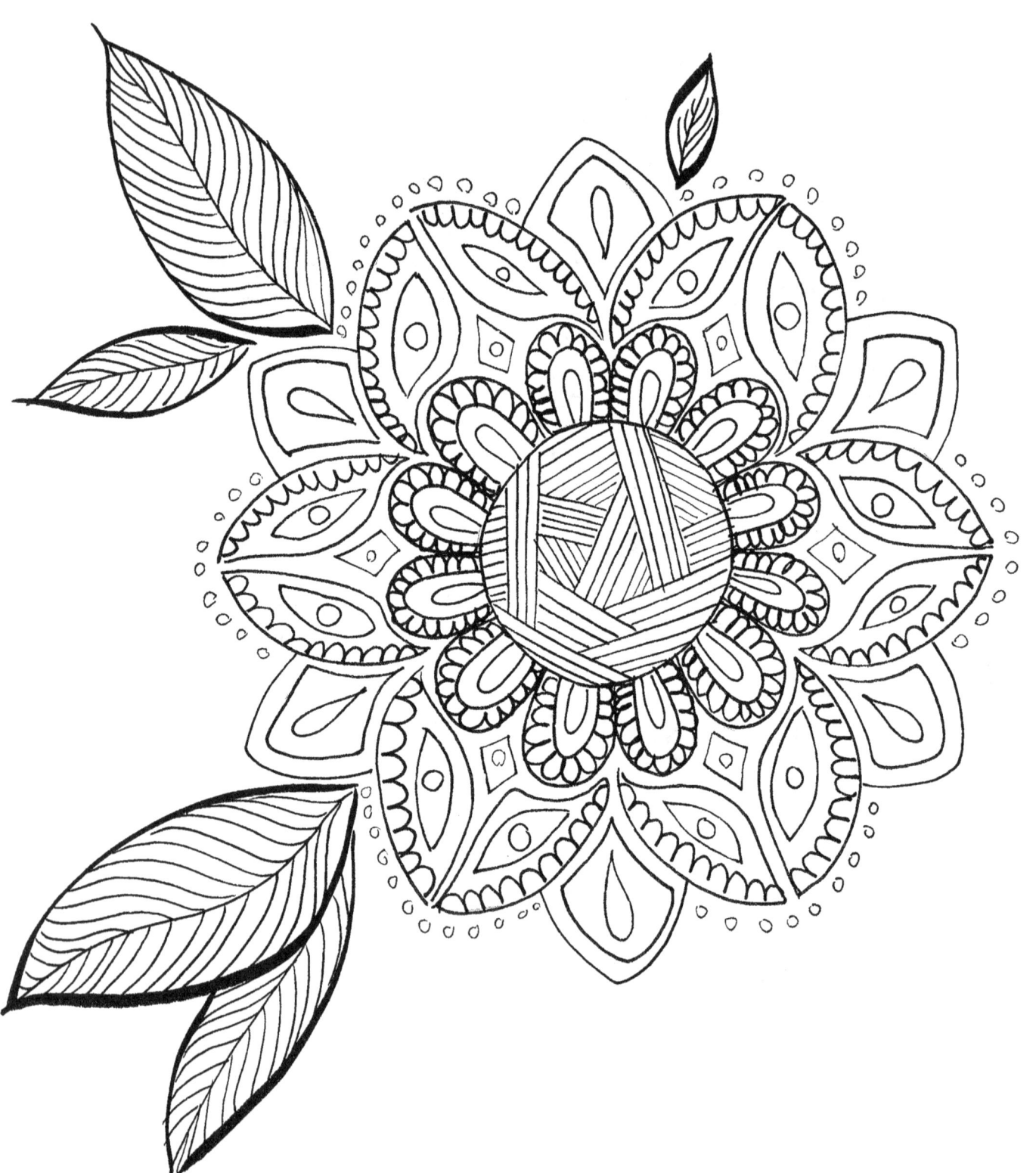

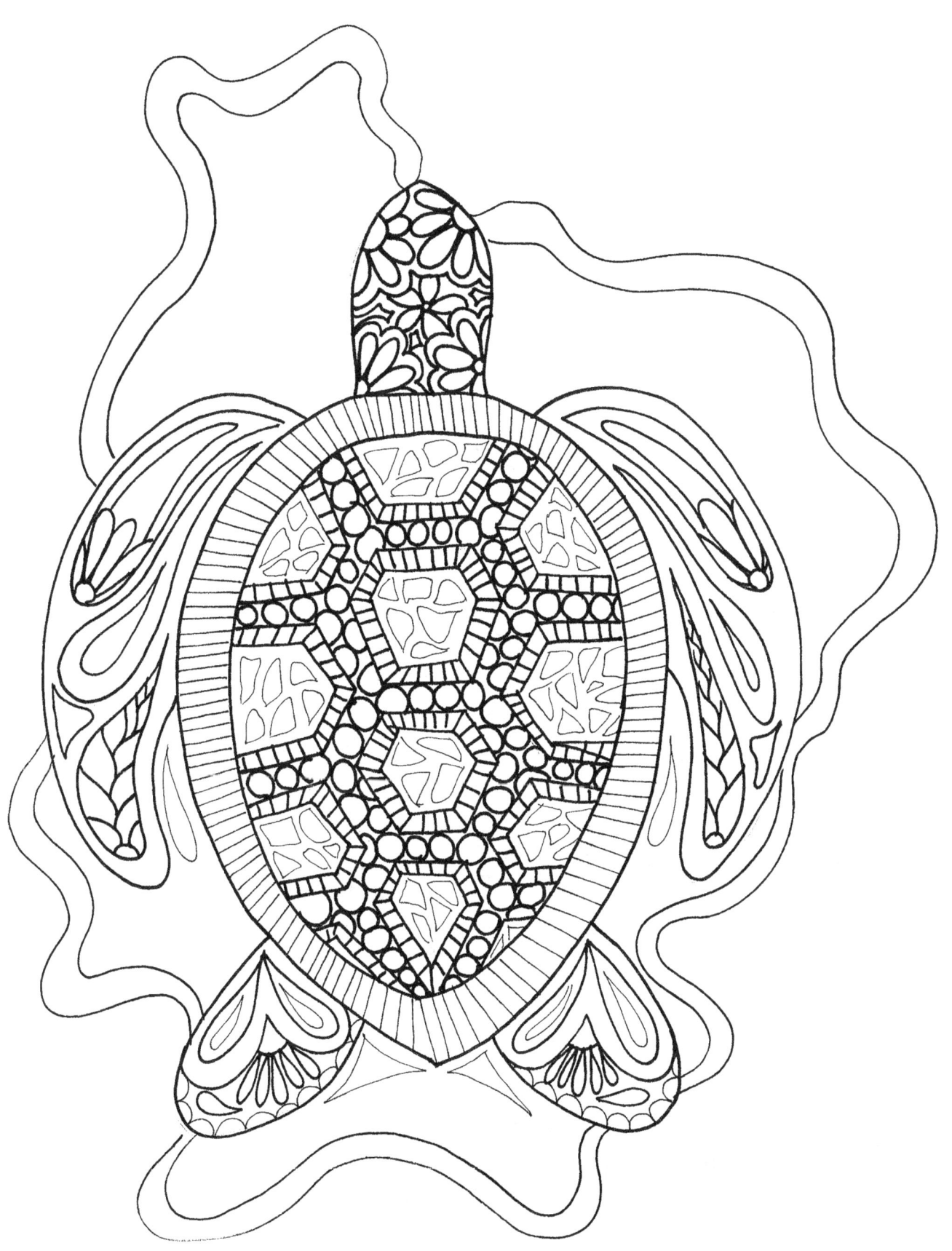

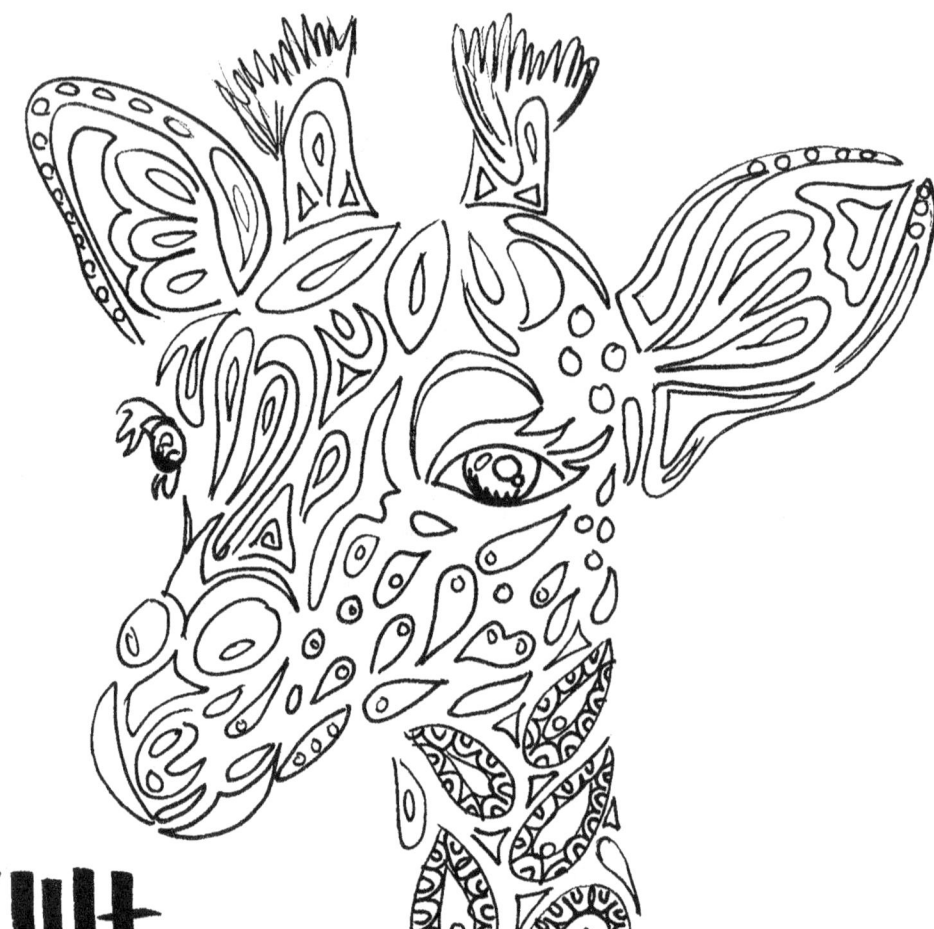

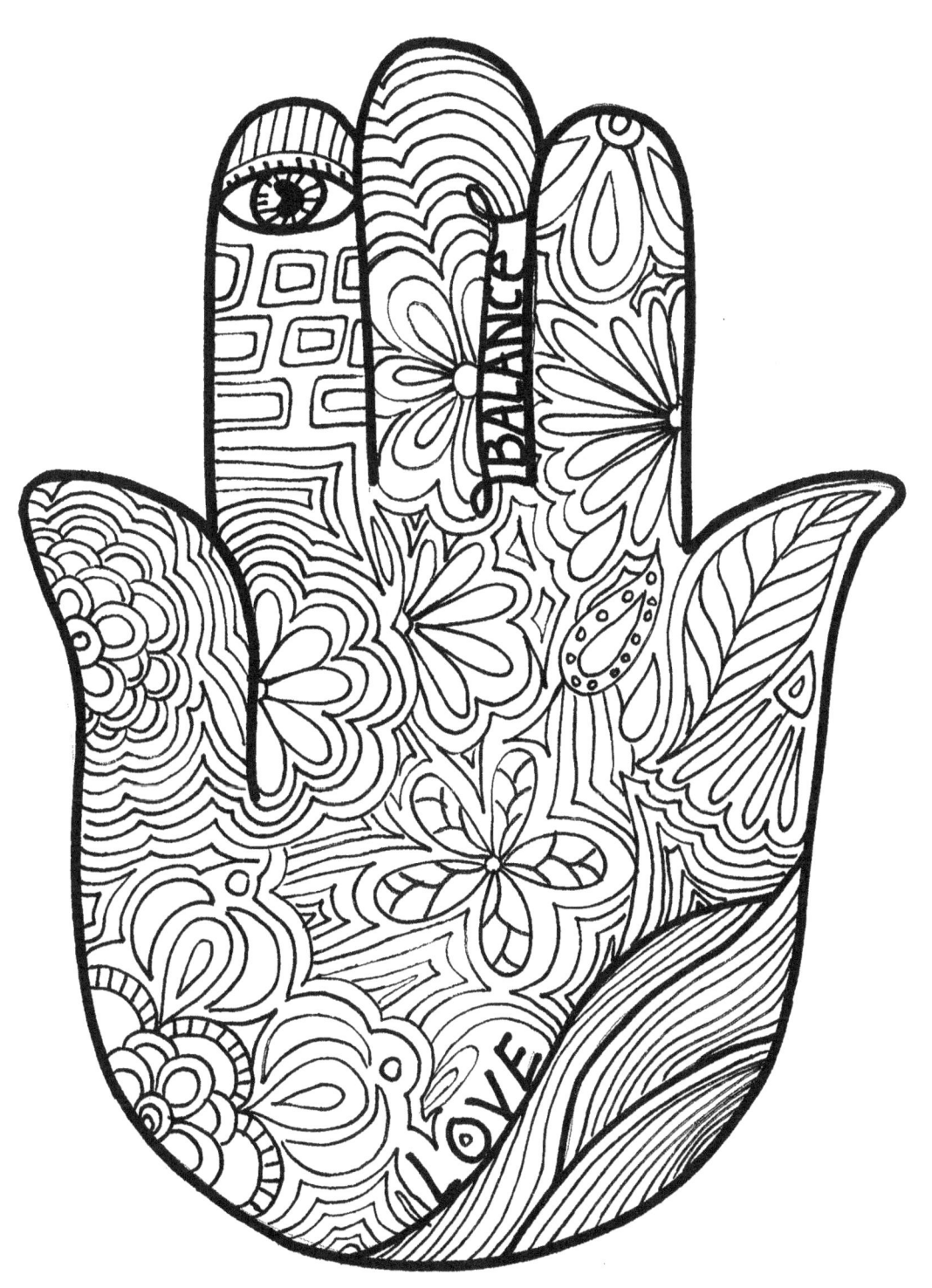

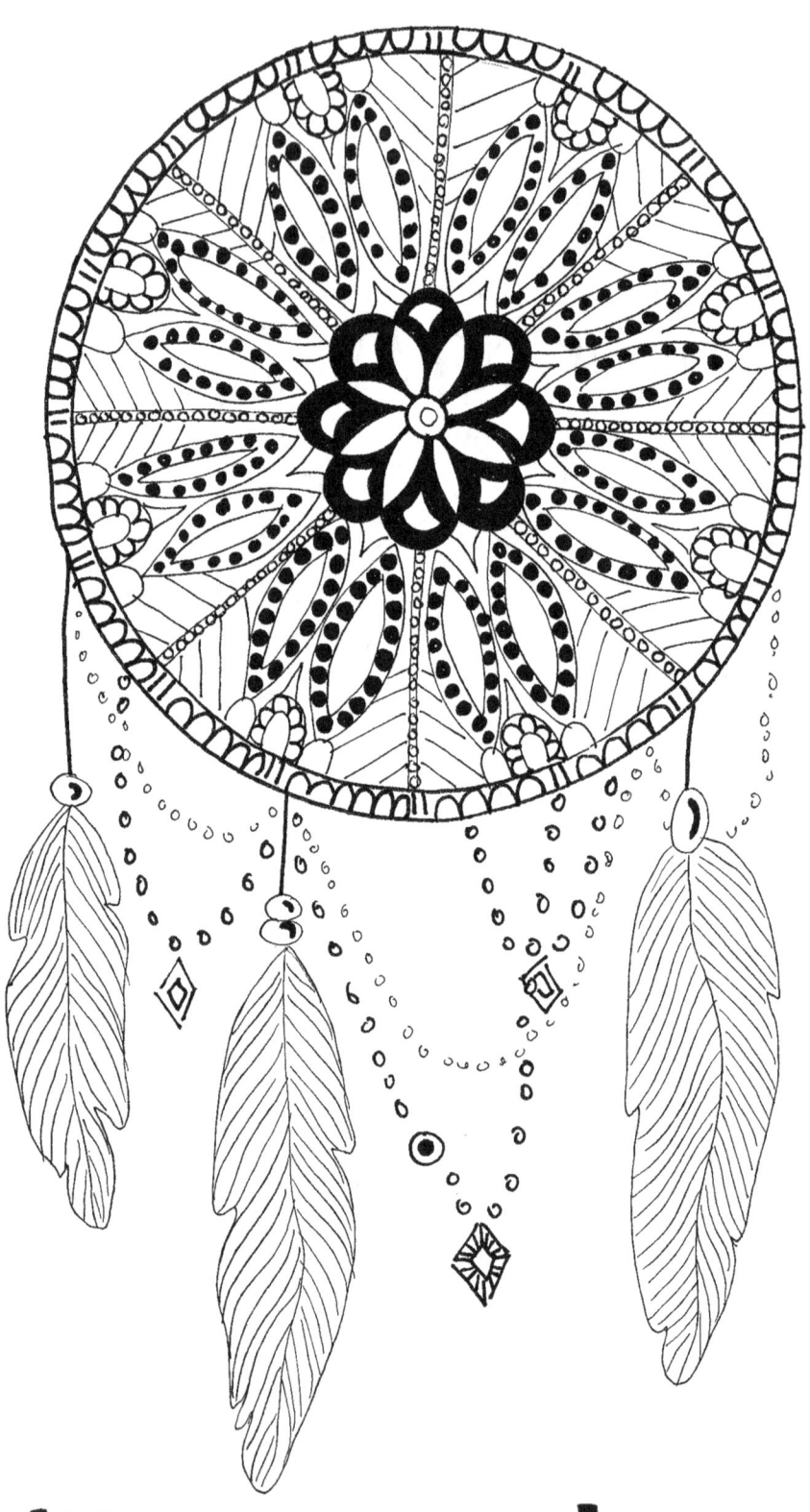

Build your own dreams...

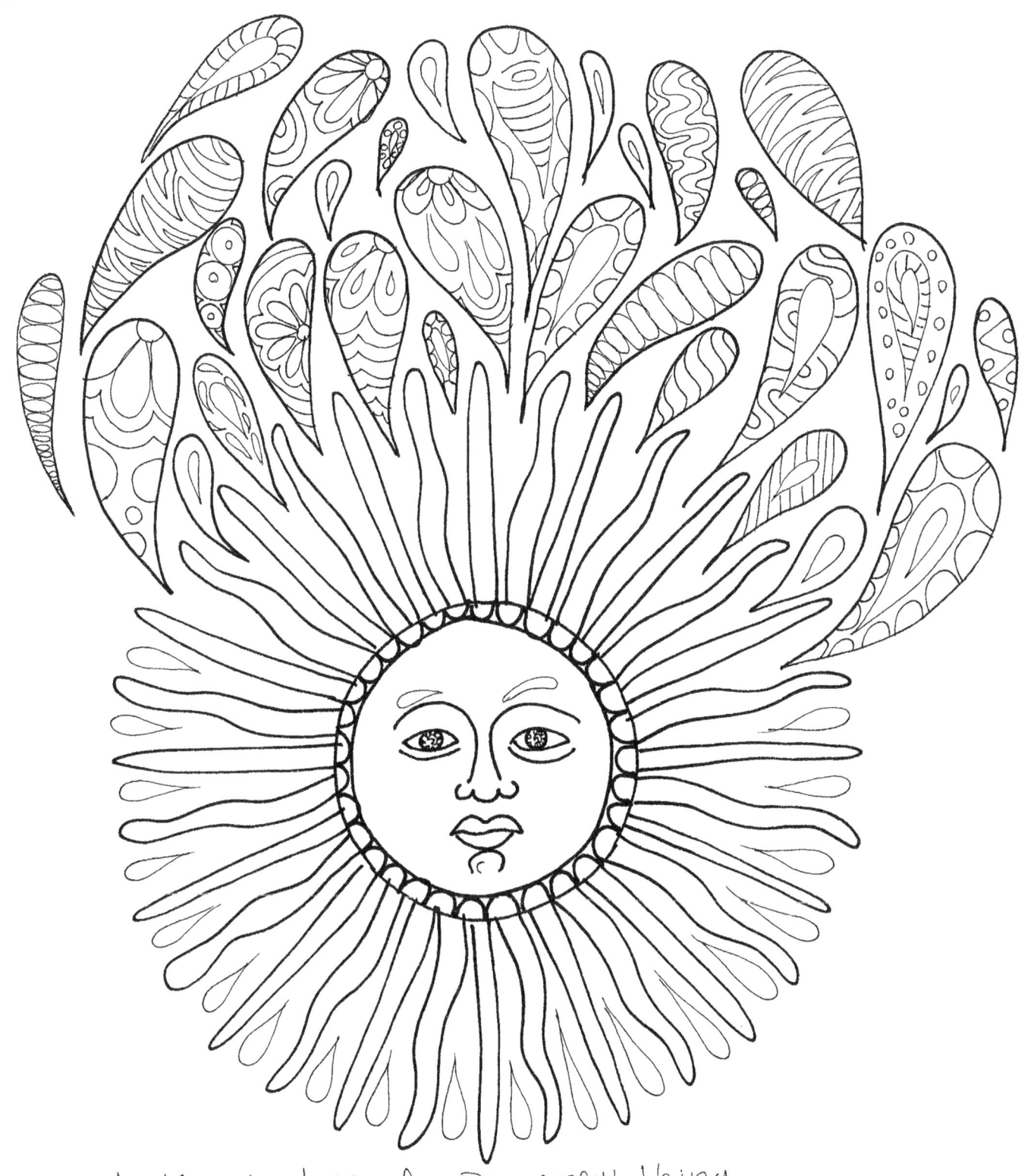

your mind is A powerful thing. when you fill it with positive thoughts, your life will start to change.

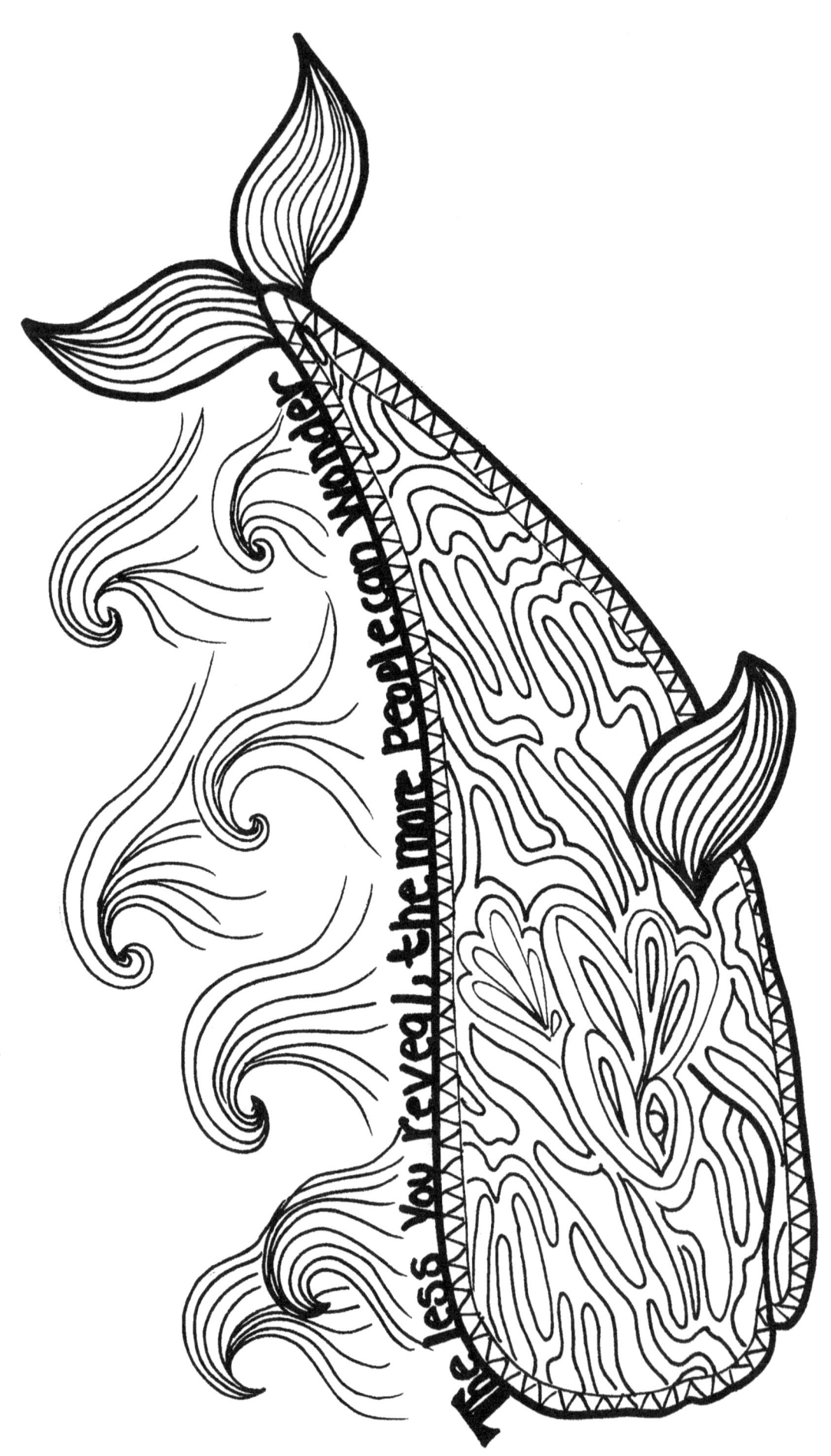

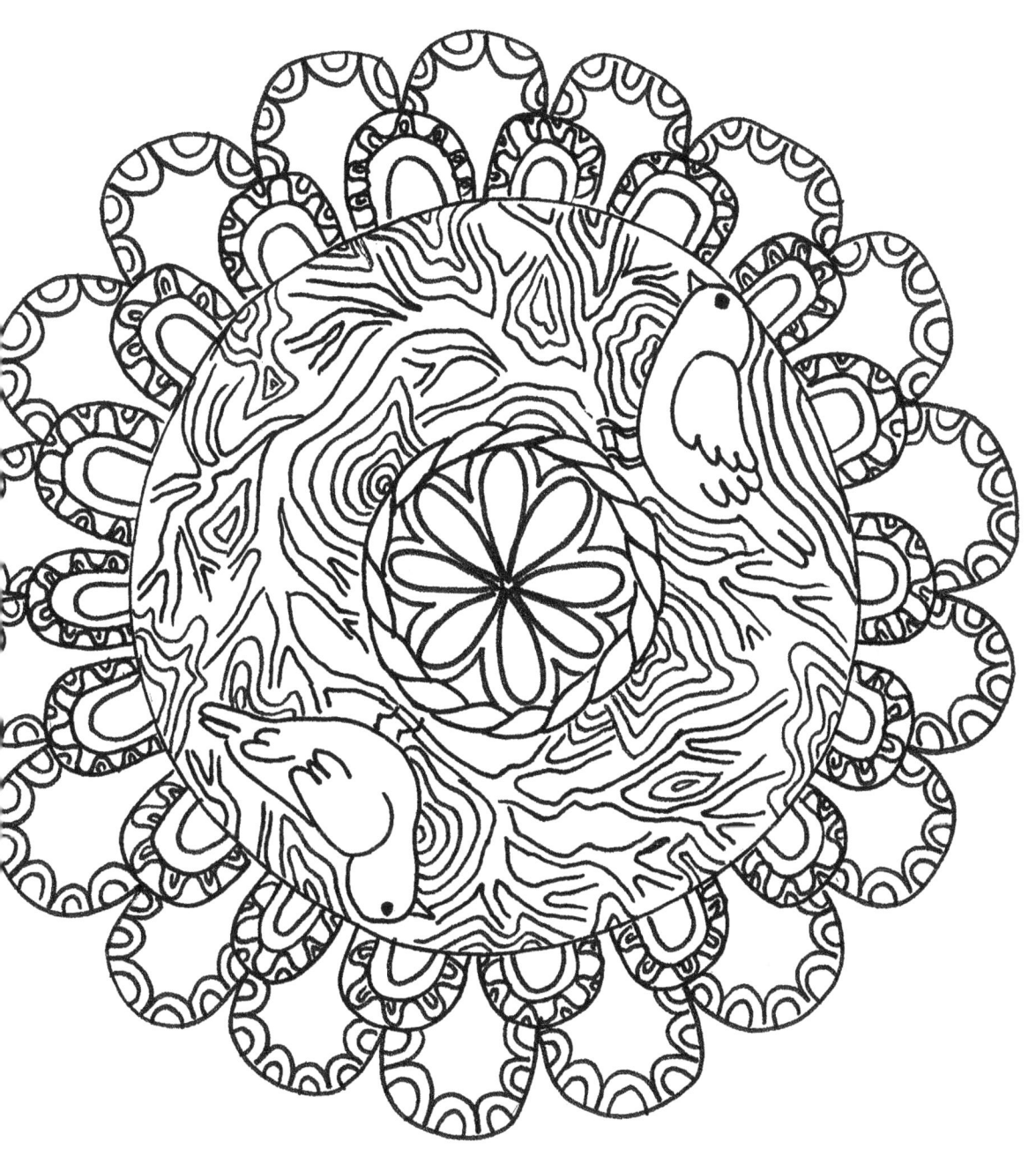

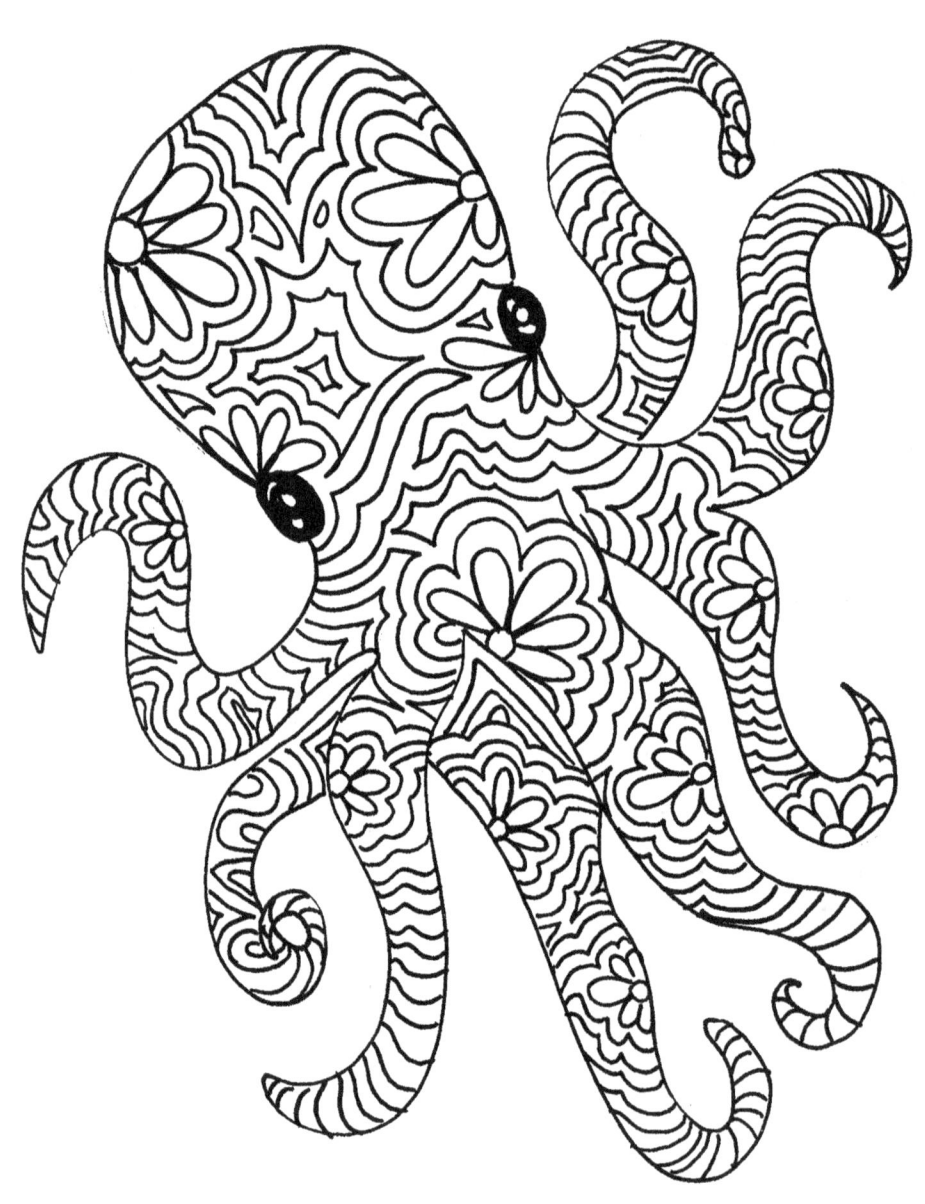

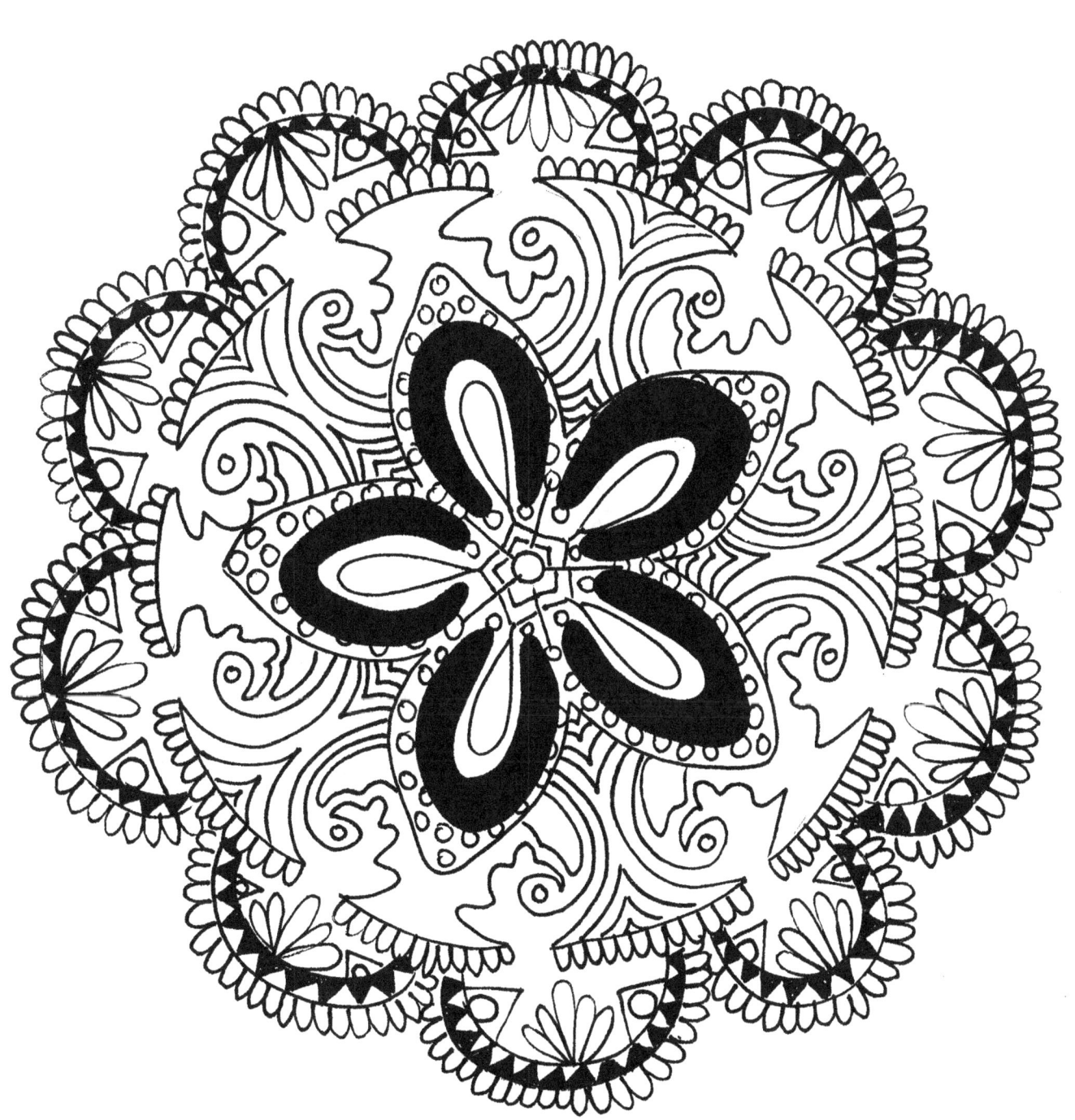

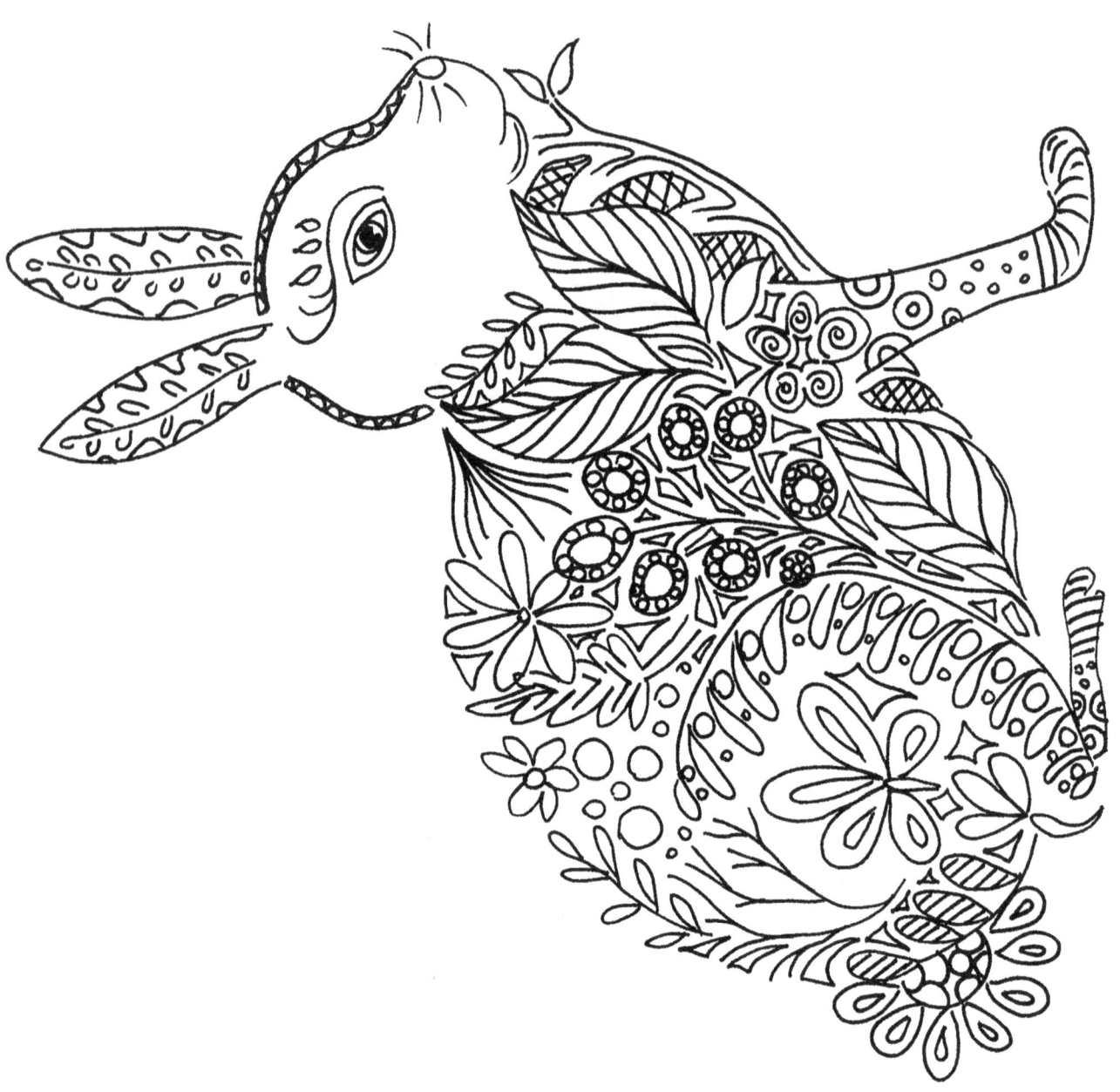

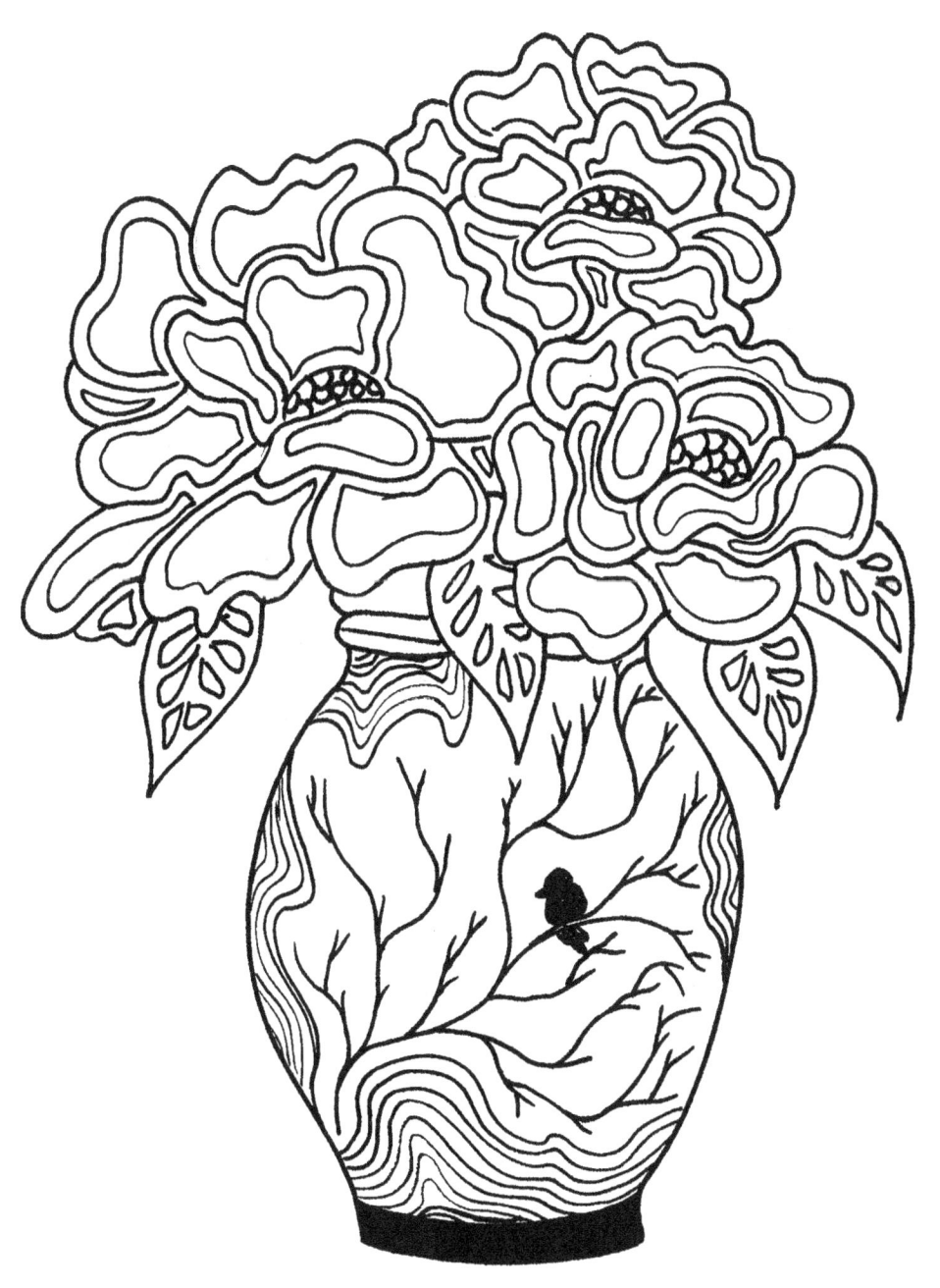

"A flower does not think of competing to the flower next to it, it just blooms" —zen shin

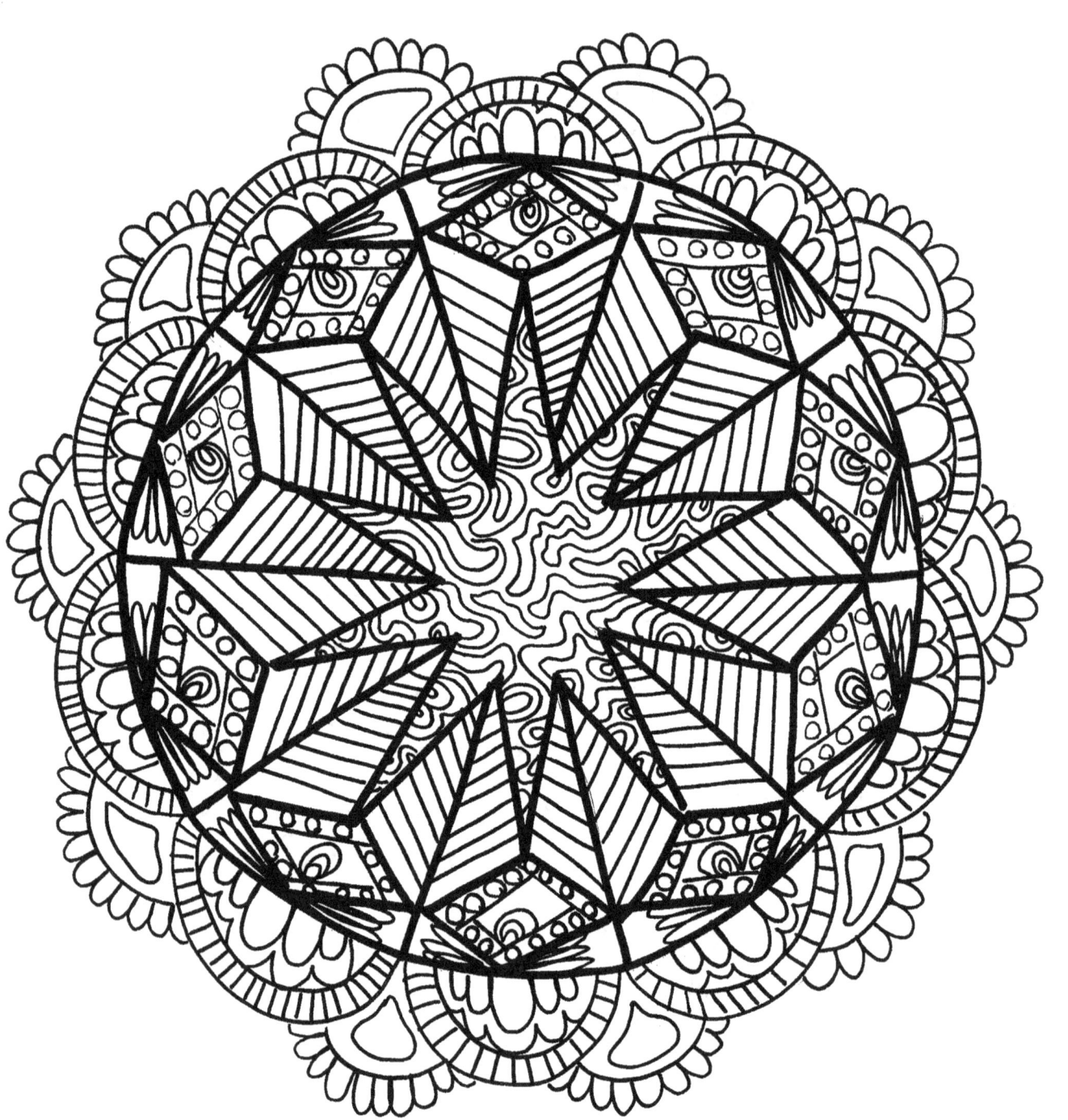

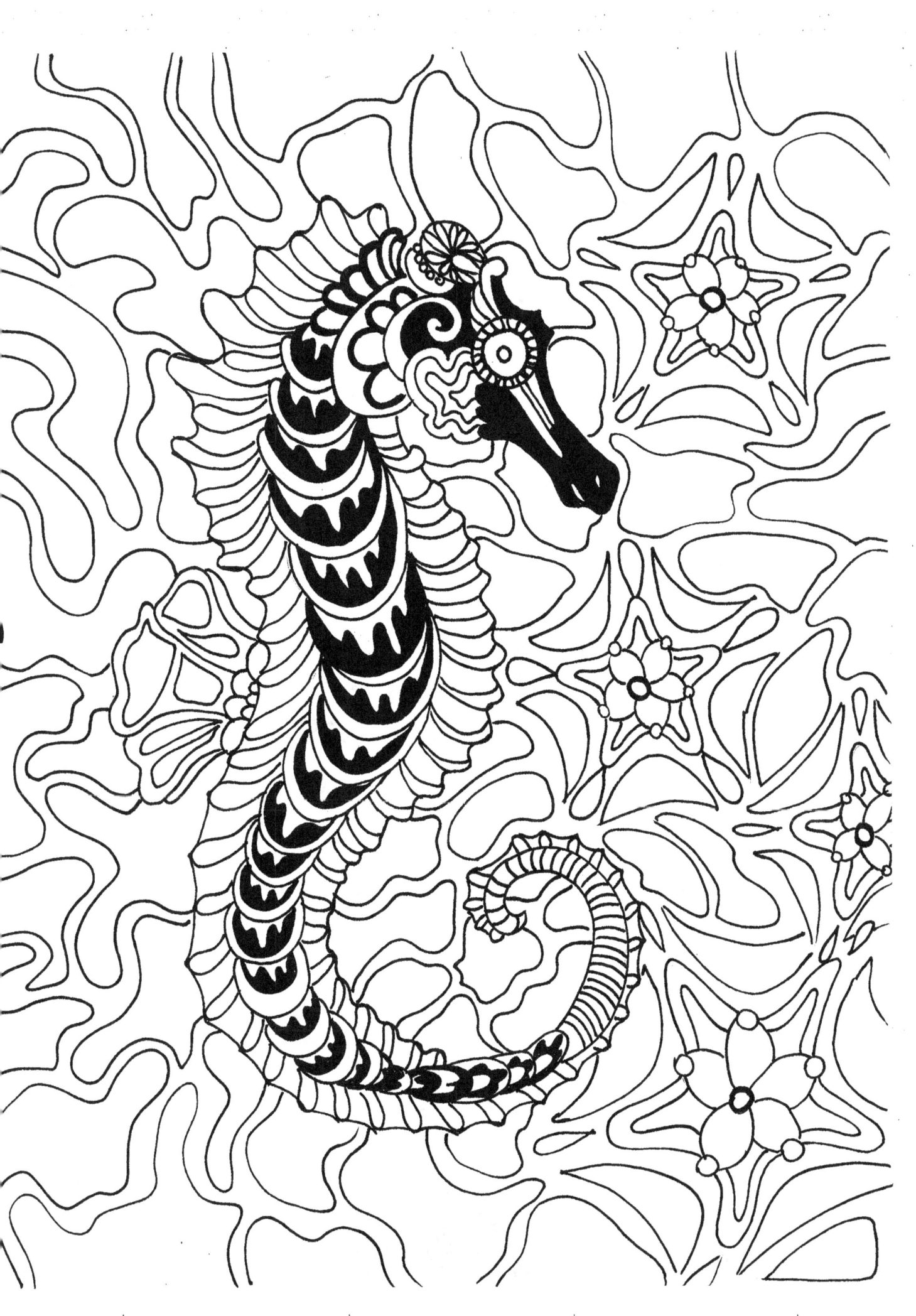

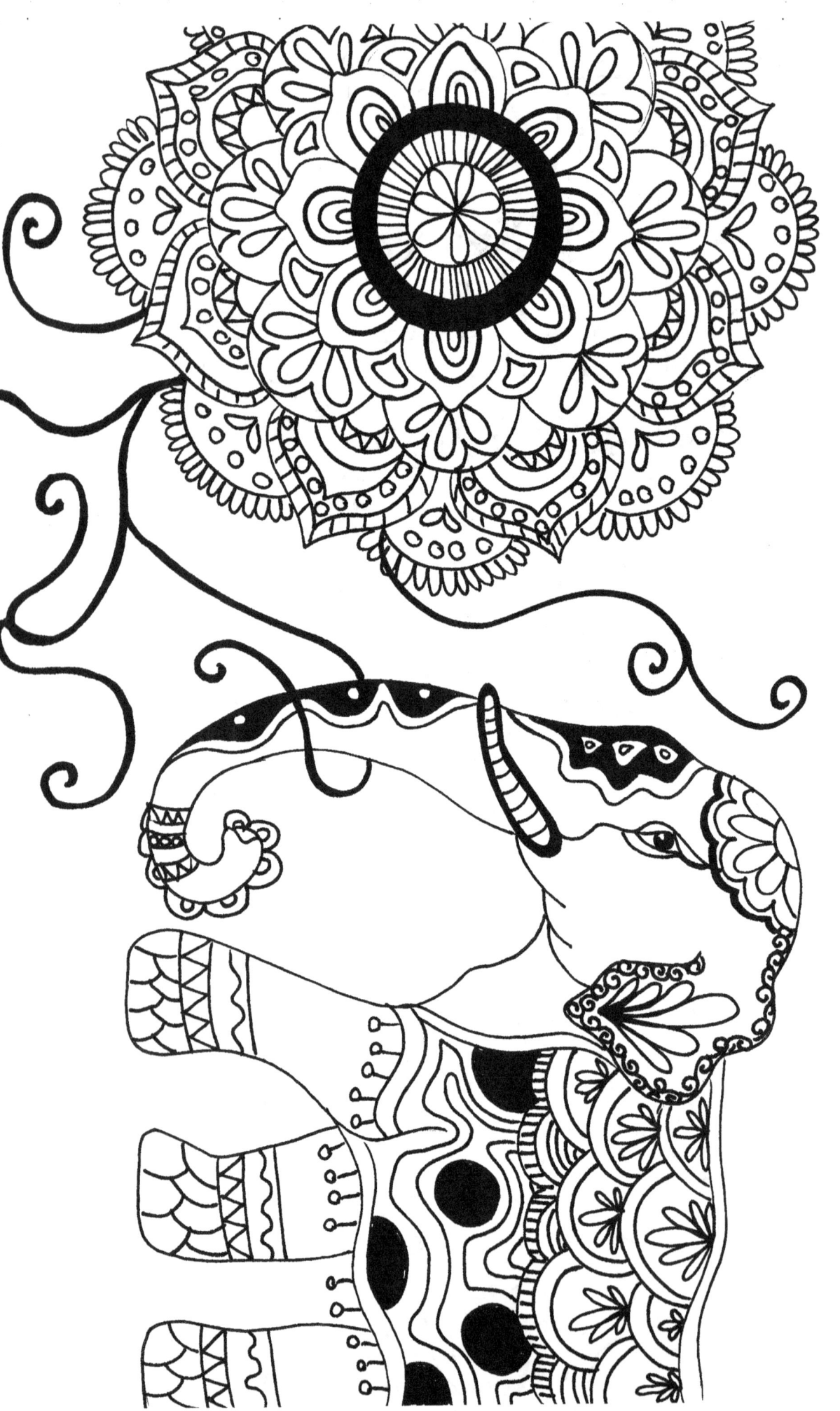

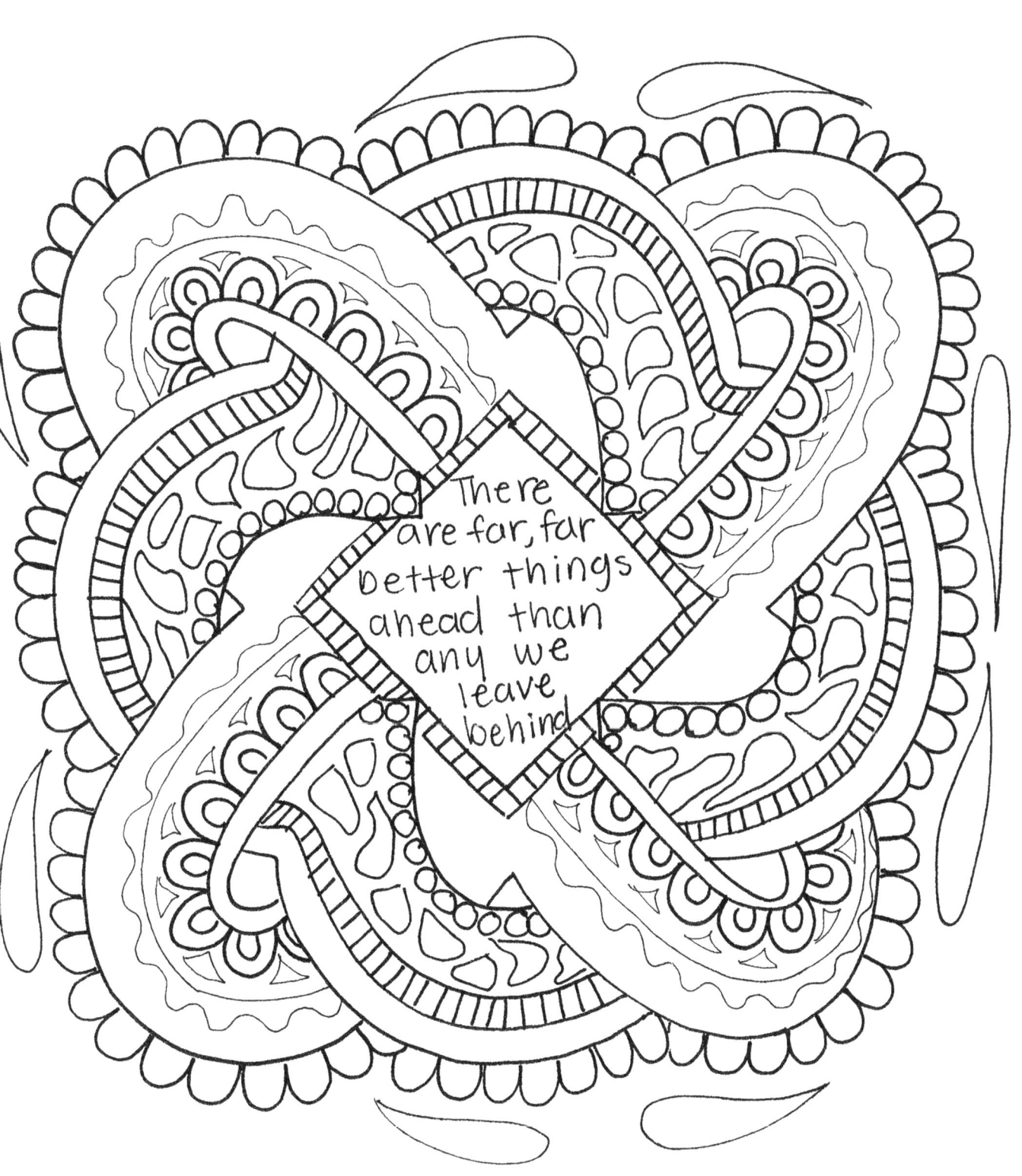

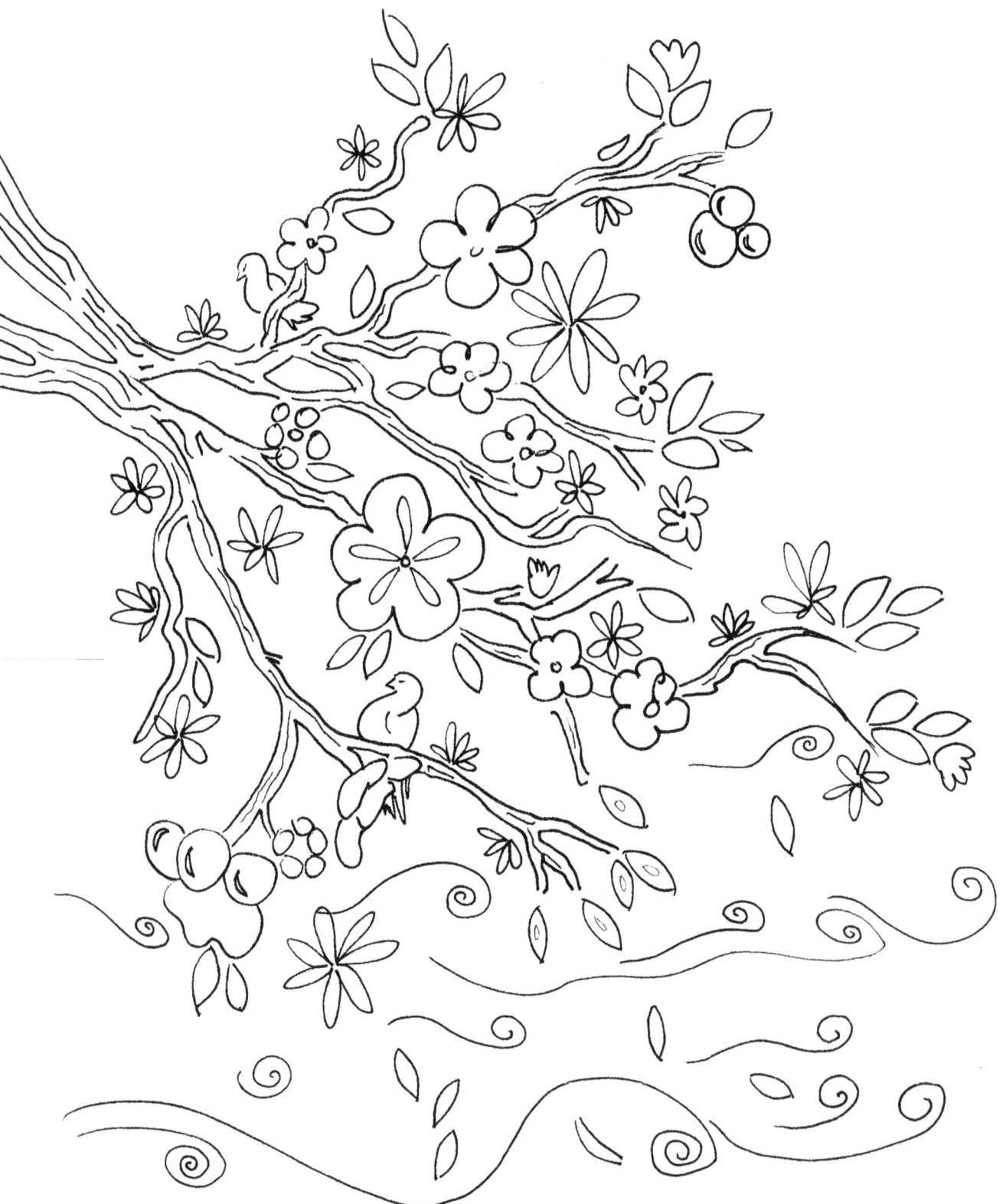

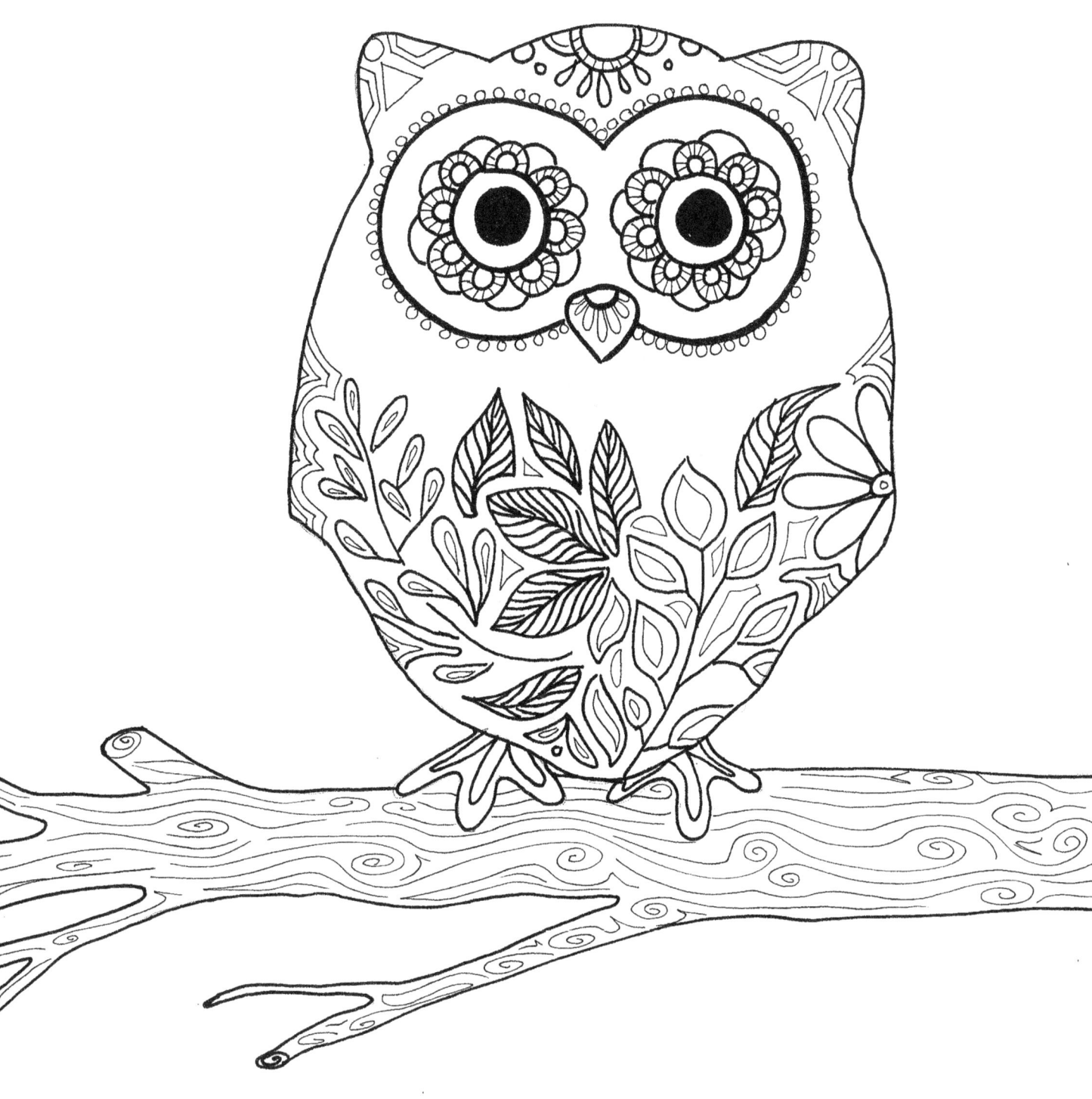

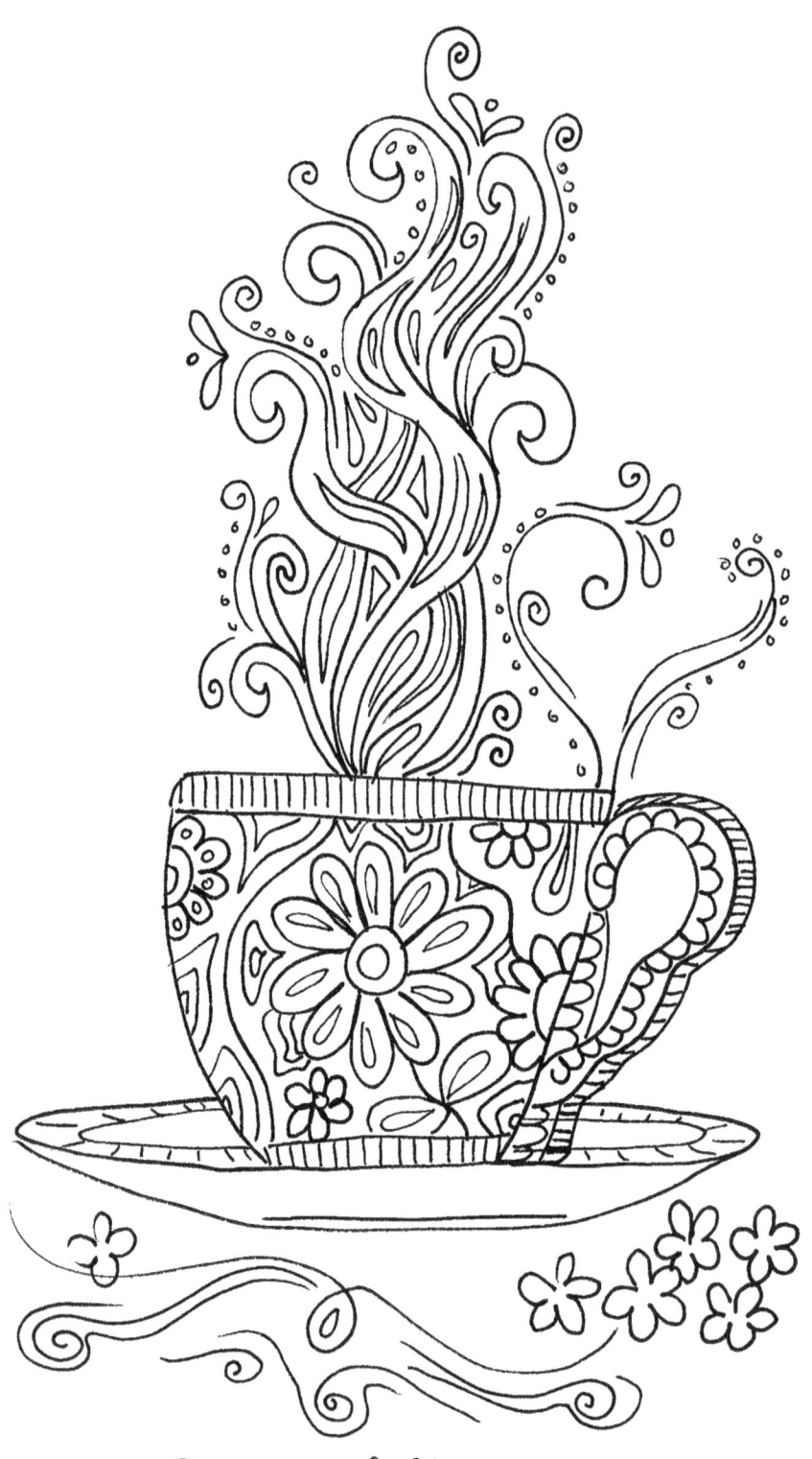

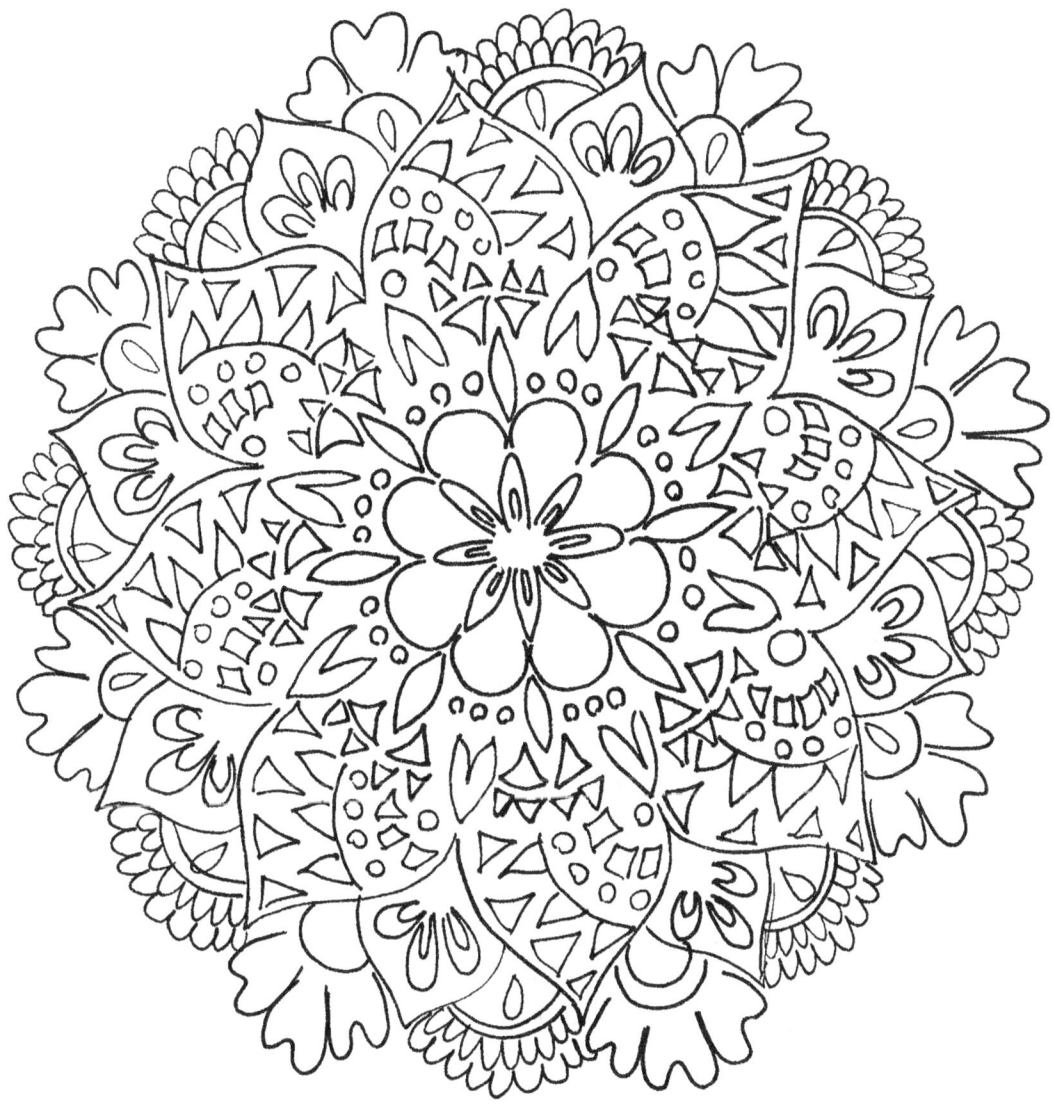

If you get tired,
Learn to rest,
Not quit.

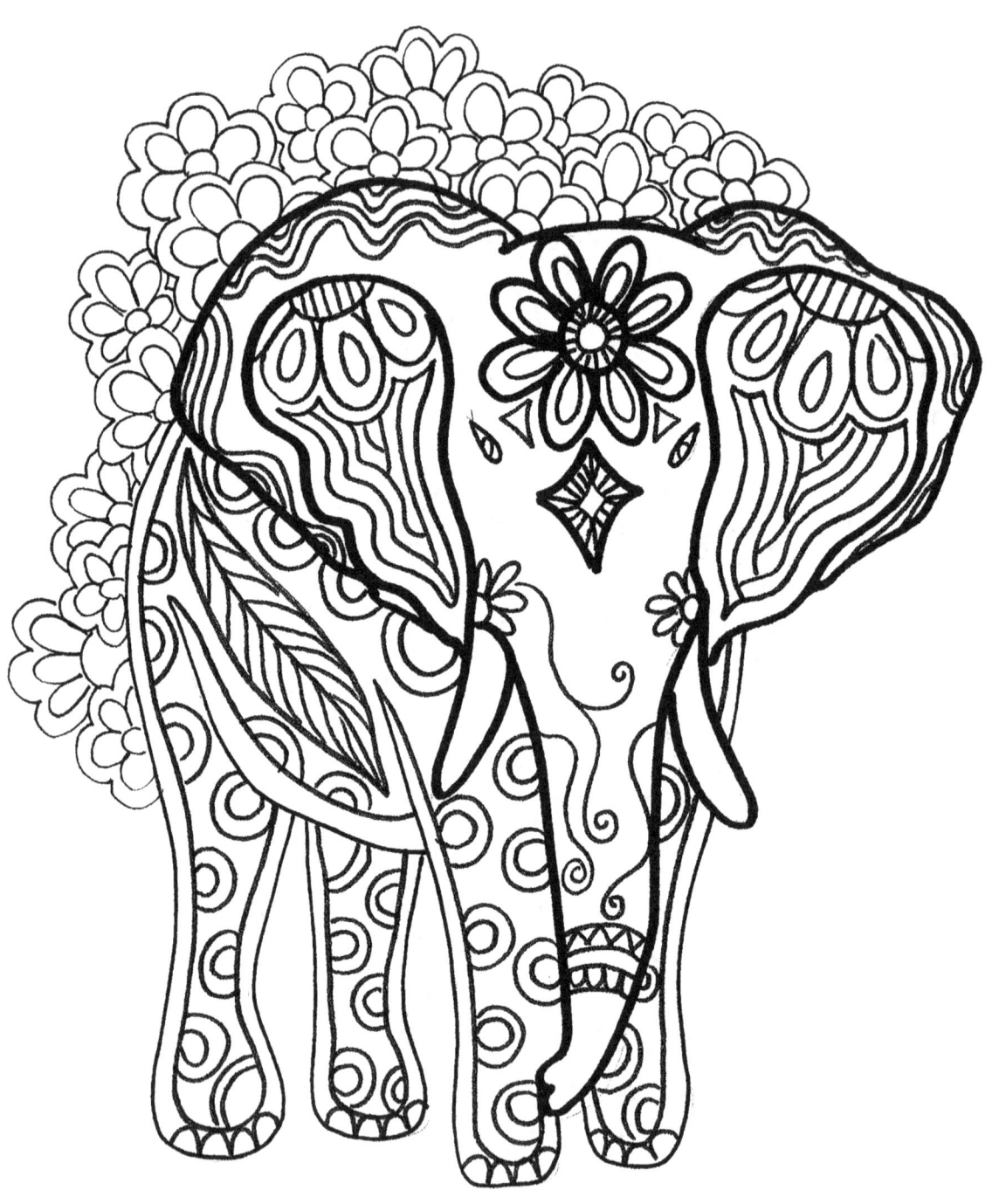

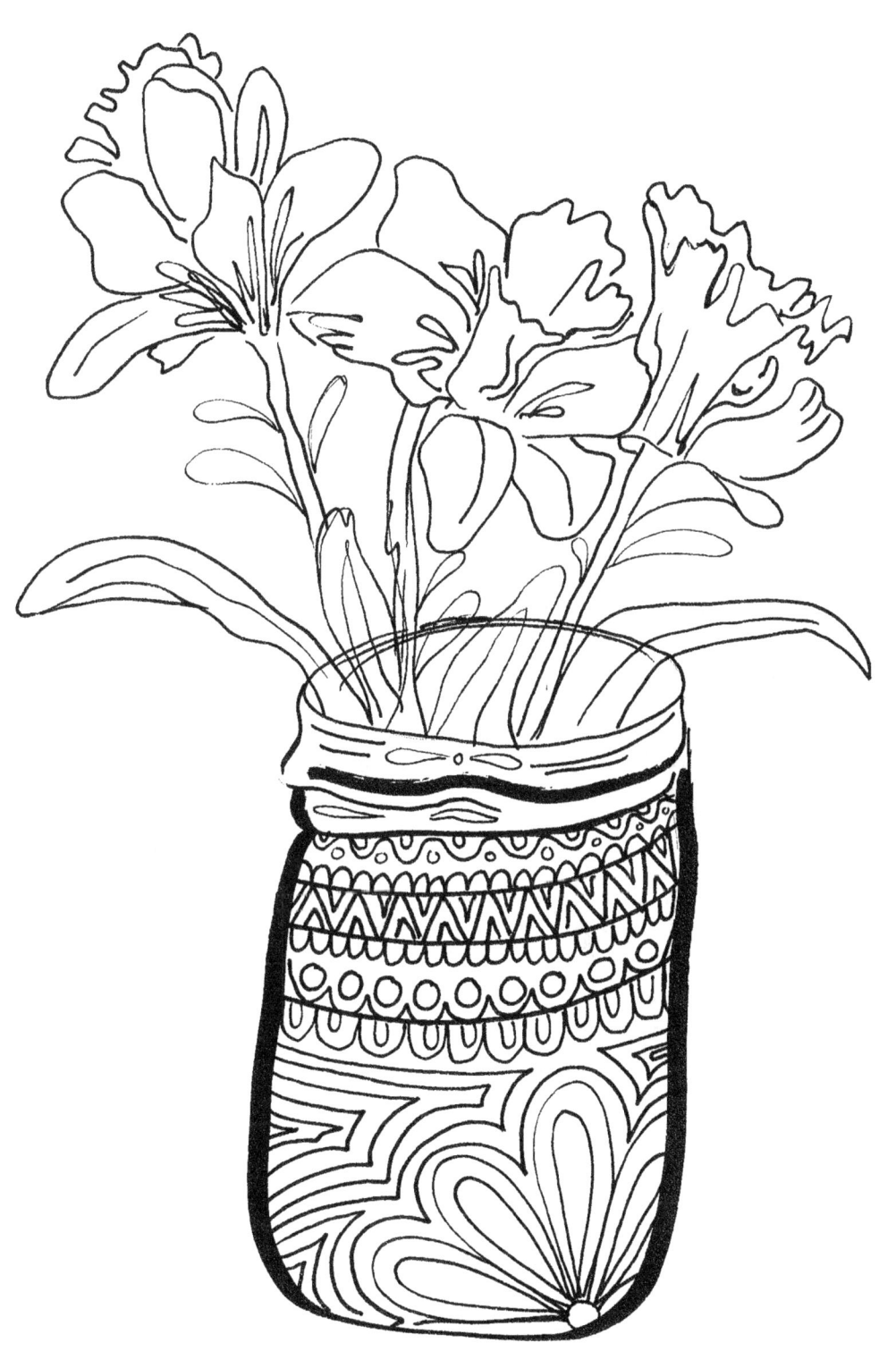

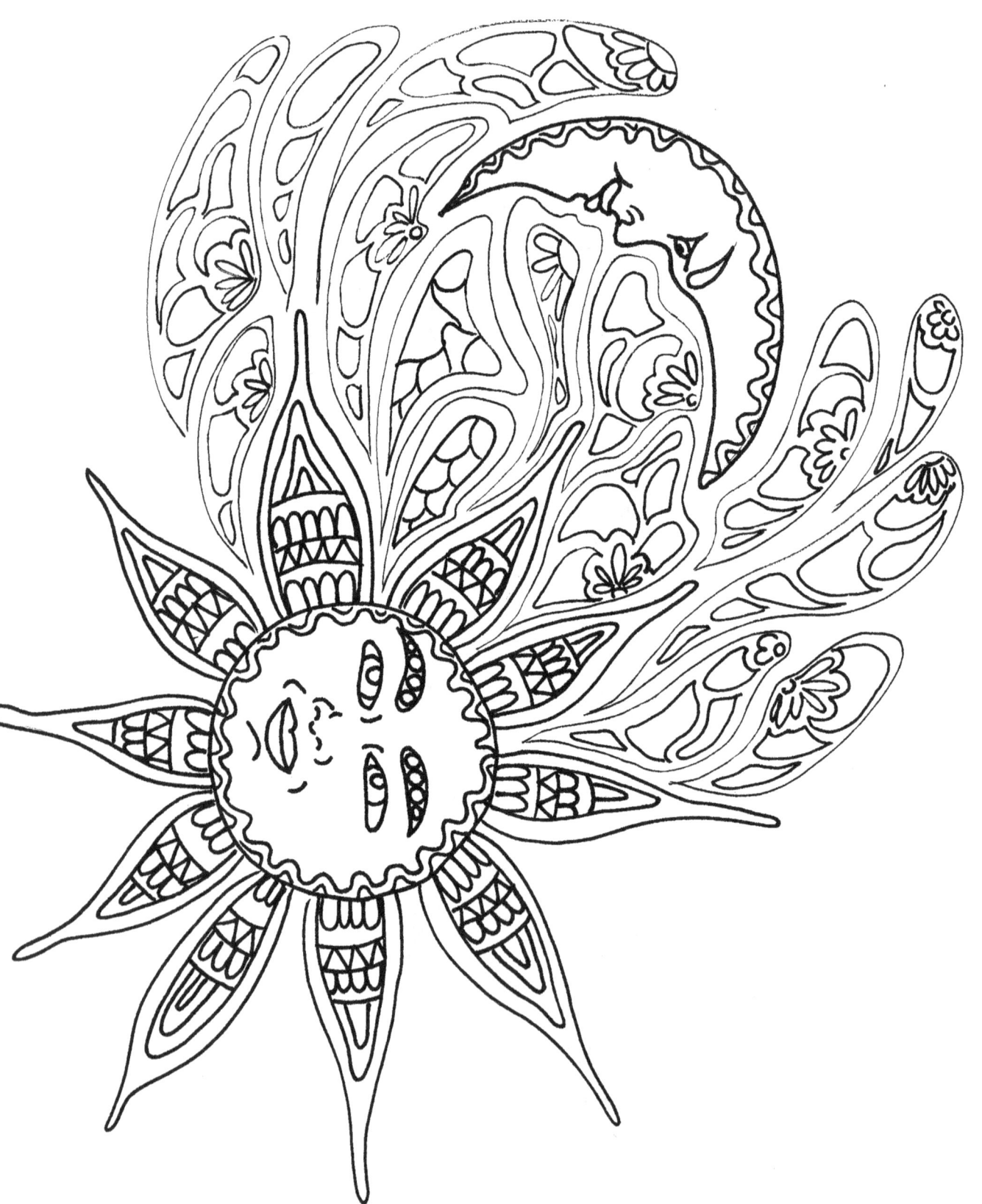

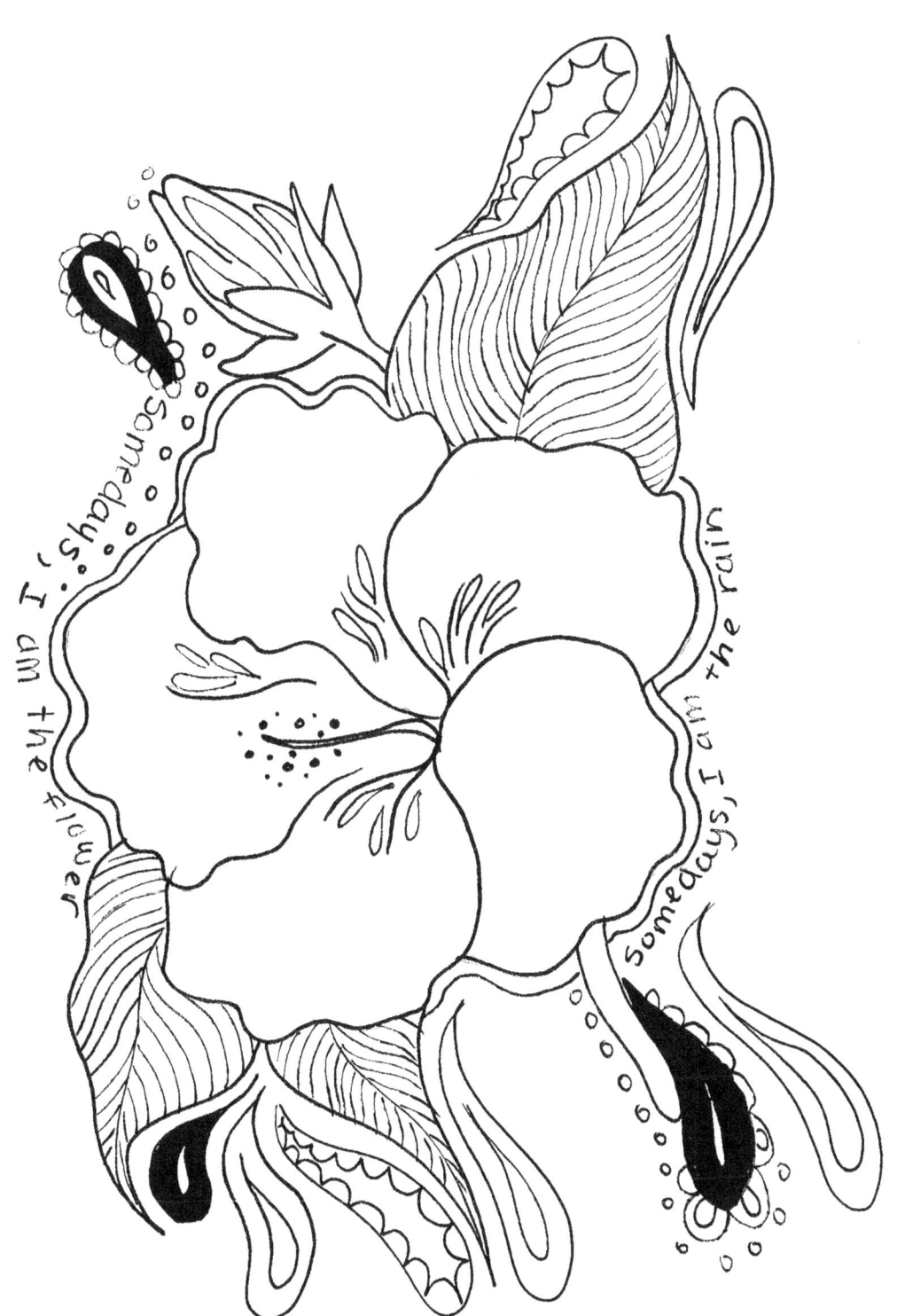

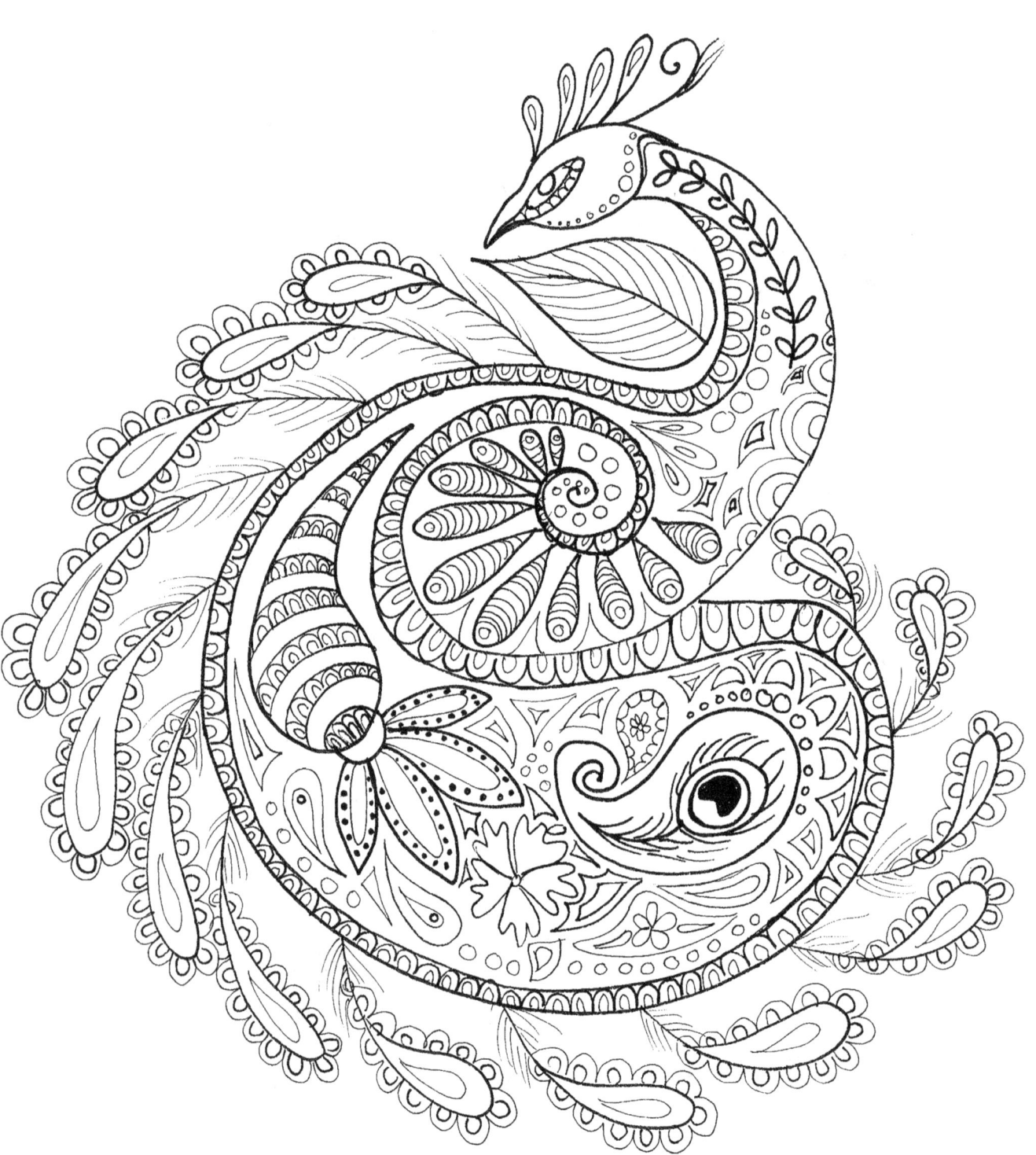

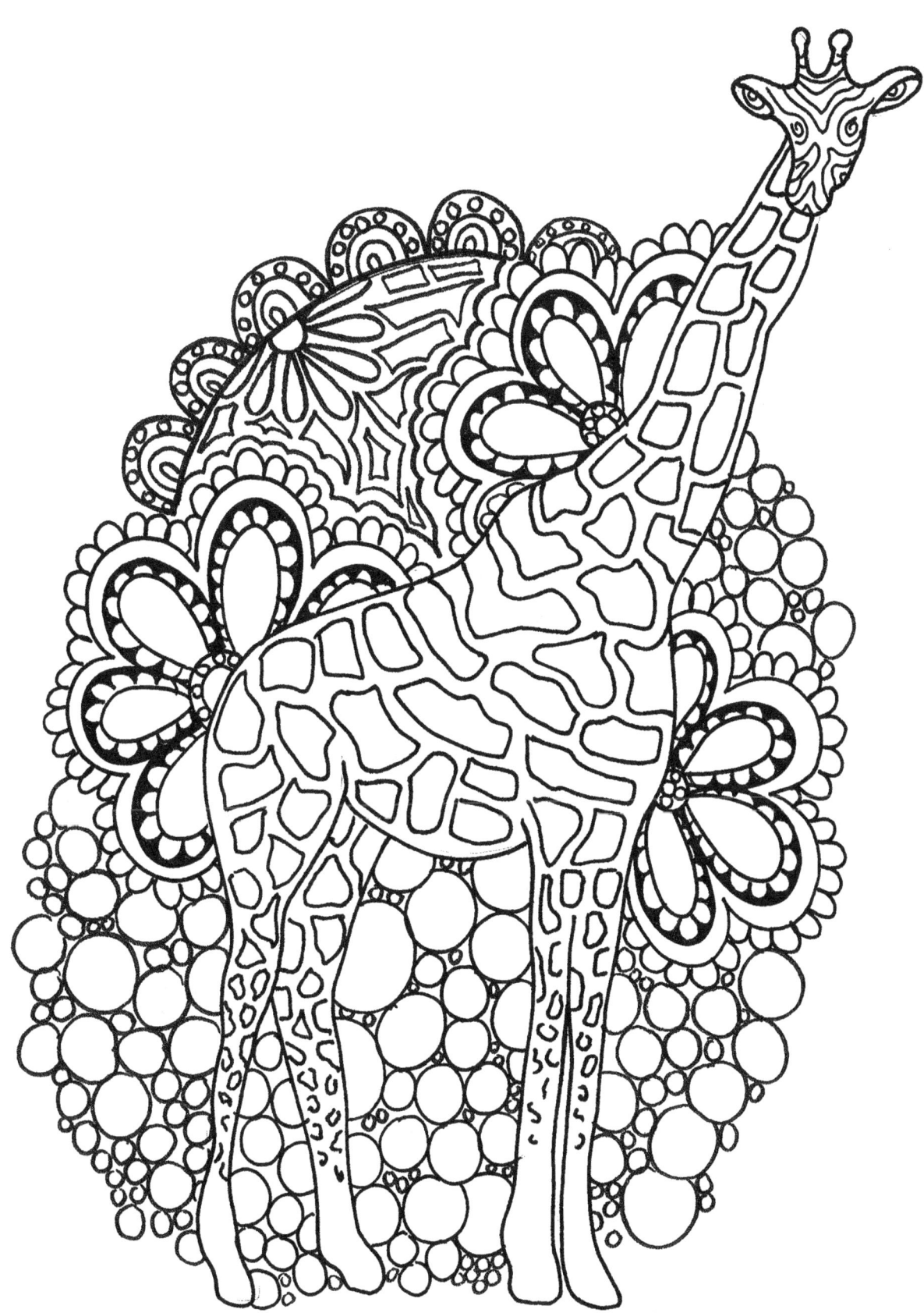

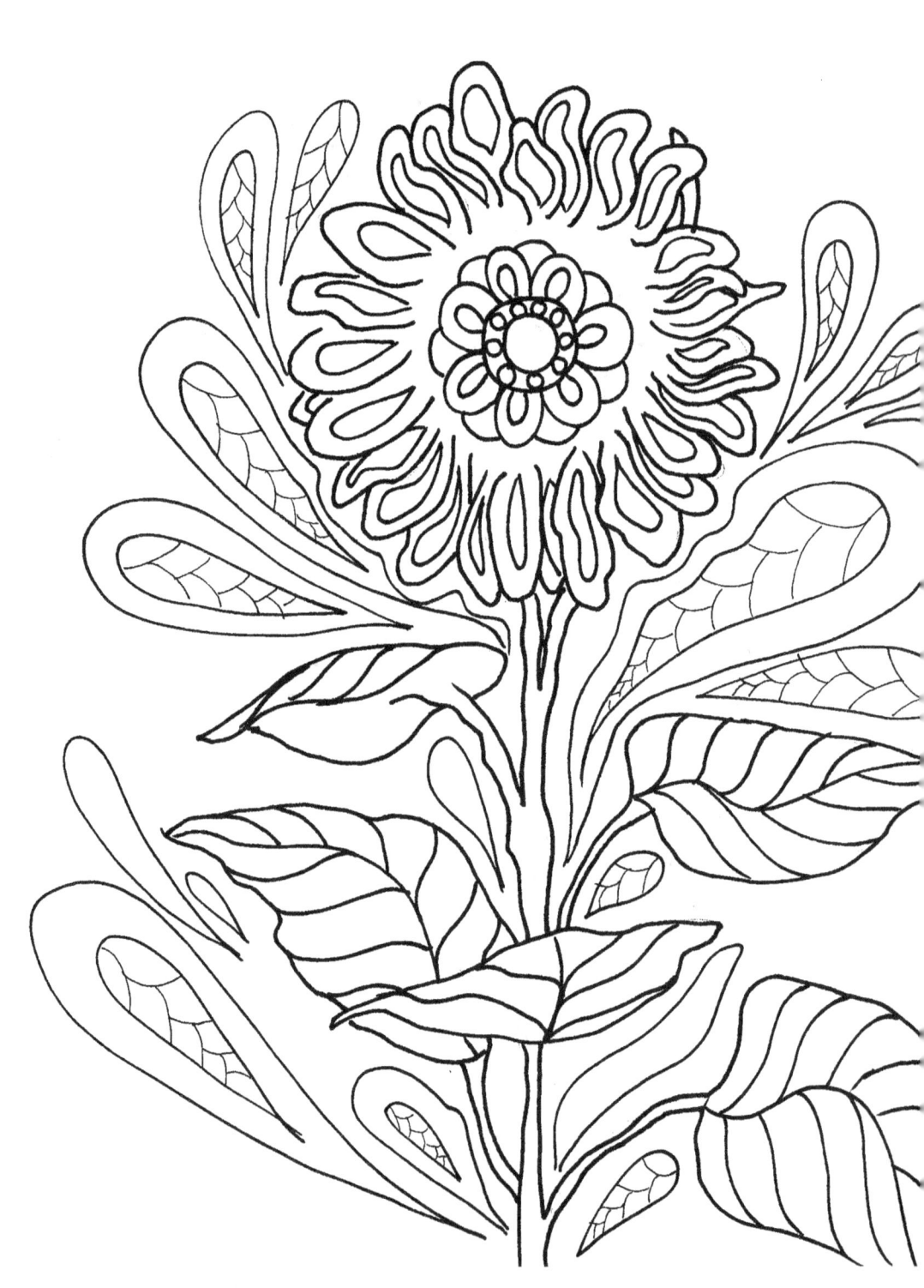

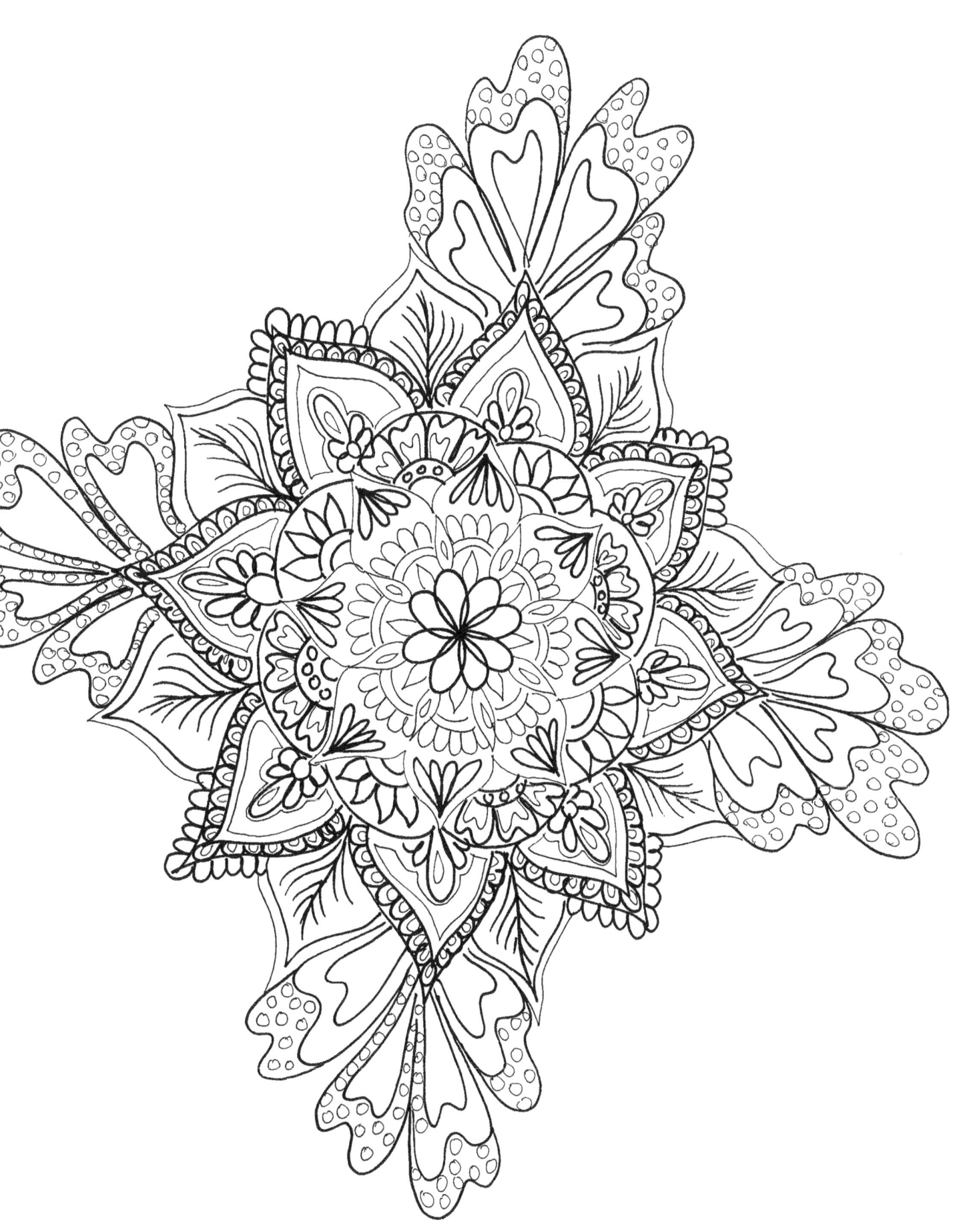

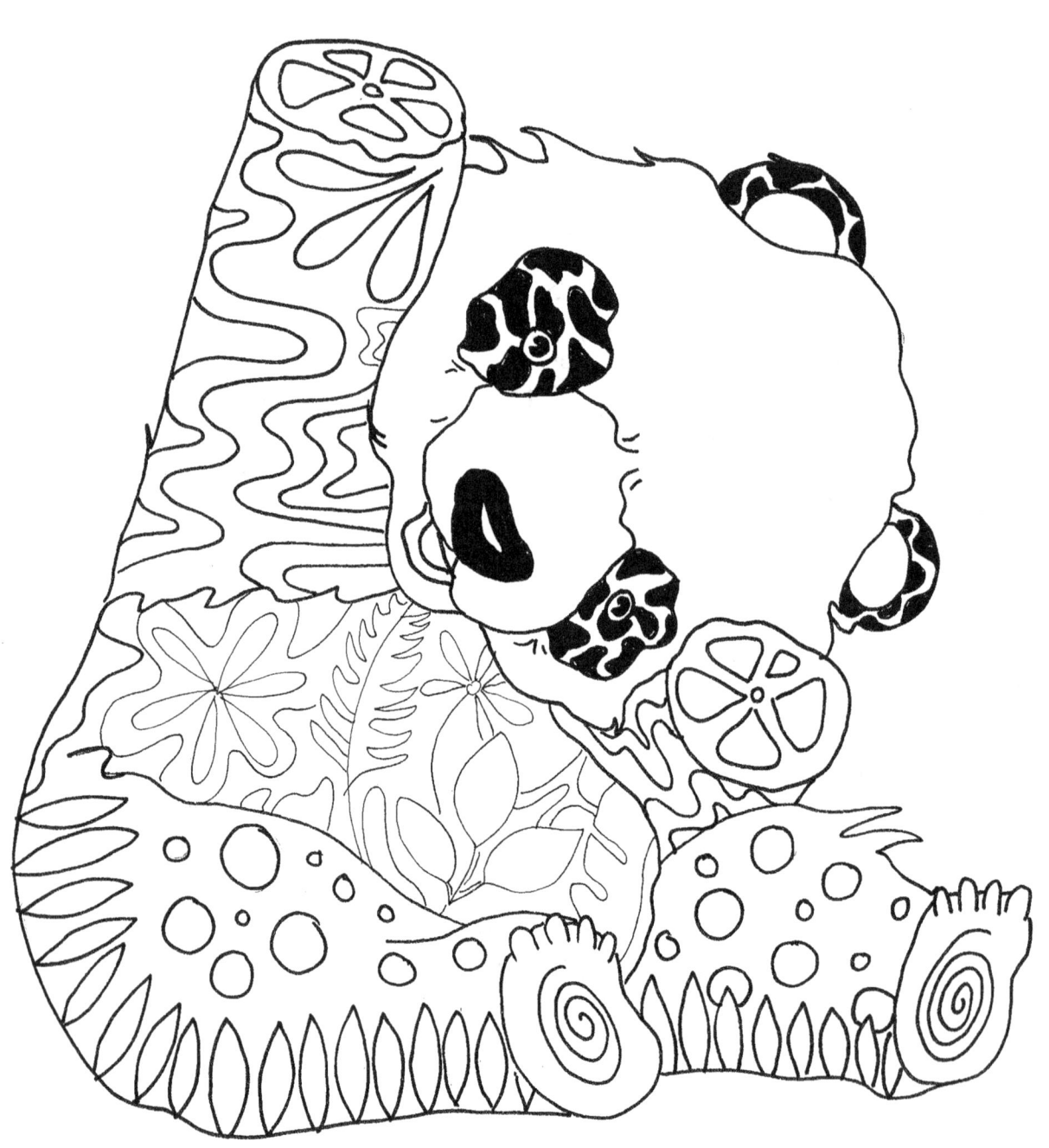

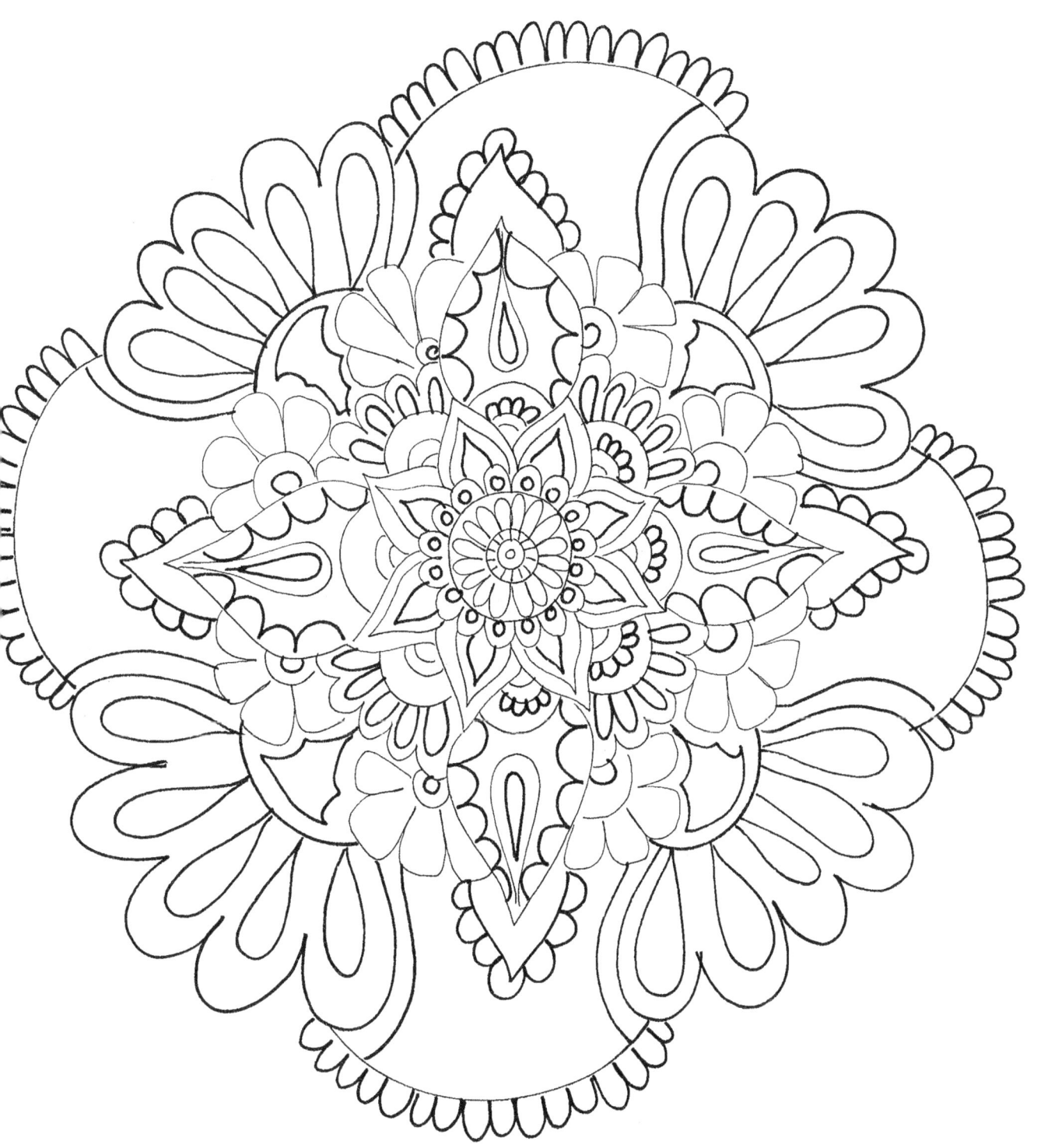

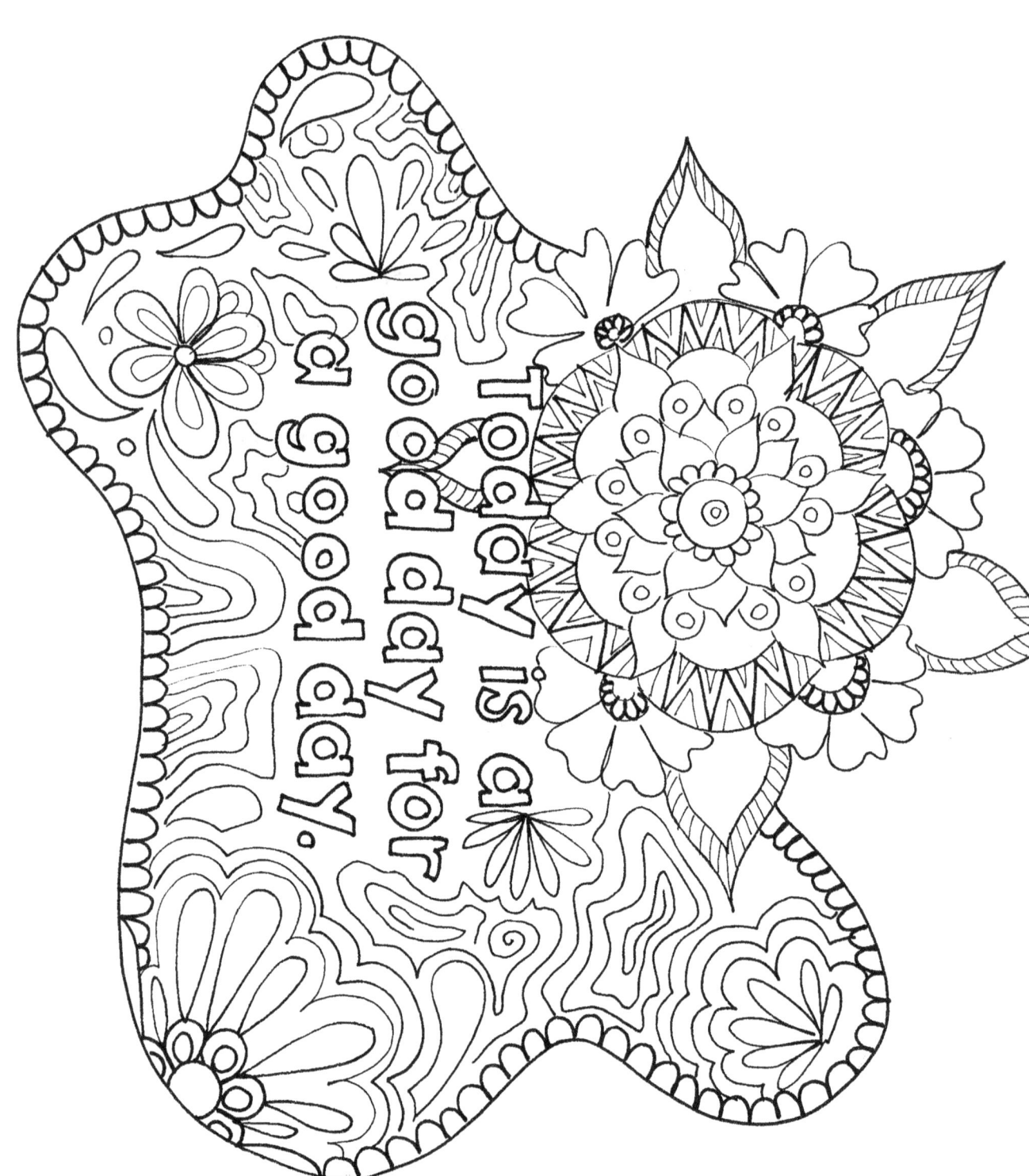

www.ingramcontent.com/pod-product-compliance
Lightning Source LLC
Chambersburg PA
CBHW080946170526
45158CB00008B/2389